Make Art
with the
Greats

ABOUT THE AUTHOR

Amy Jane Adams (AJ) is a British author, painter, installation artist, illustrator, photographer and set designer. She is particularly obsessed with buildings and the people who lived in them and is inspired by the Italian Renaissance, pop art and graffiti. Her clients include fashion designer Jenny Packham, the Royal Institute of British Architects (RIBA) and the Church of England.

She has exhibited at the Courtauld Institute of Art (2010) and at Gloucester Cathedral (2017), which became host to a thirty-metre length of 'carpet' designed by the artist and painted on by over one thousand visitors to the world-famous heritage site. She lives and works near London.

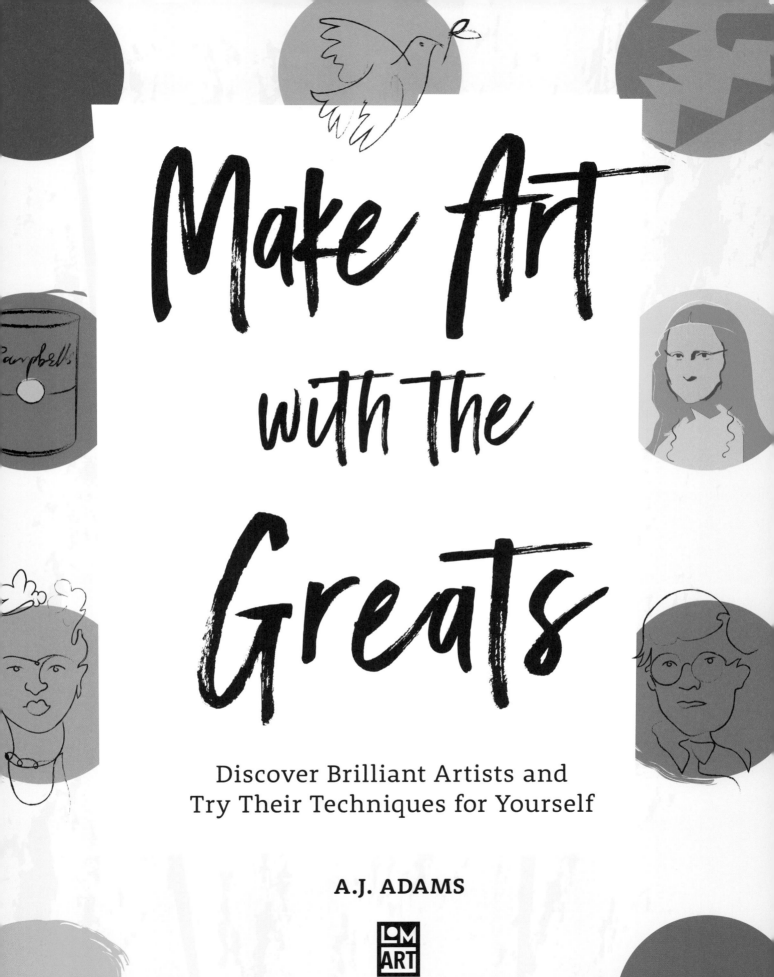

Make Art with the Greats

Discover Brilliant Artists and Try Their Techniques for Yourself

A.J. ADAMS

LOM ART

To the publisher for giving me the opportunity
to create this book. And to my one-year-old son, Winston.
You allowed me to complete it by sleeping so well.

First published in Great Britain in 2024 by LOM ART, an imprint of
Michael O'Mara Books Limited
9 Lion Yard
Tremadoc Road
London SW4 7NQ

Copyright © Michael O'Mara Books Limited 2024
Written, illustrated and art directed by A.J. Adams
Additional images from Shutterstock

A CIP catalogue record for this book is available from the British Library.

Papers used by Michael O'Mara Books Limited are natural, recyclable products made from
wood grown in sustainable forests. The manufacturing processes conform to the environmental
regulations of the country of origin.

ISBN: 978-1-912785-60-5 in paperback print format
1 2 3 4 5 6 7 8 9 10
Printed and bound in China
www.mombooks.com

Contents

INTRODUCTION

Matisse drew from his bed, Picasso painted at the kitchen table, Damien Hirst paints on the floor, Frida Kahlo liked the garden, Hockney draws his sleeping dogs and Warhol was always in the kitchen cupboards. One thing's for sure, it's very possible to create a masterpiece at home. With this activity book, you'll learn how to create like one of the Greats.

Make your very own energetic human figure like Keith Haring, draw a self-portrait like Picasso, make a colourful, expressive mess like Jean-Michel Basquiat. Understand conceptual art a bit more with thought-provoking tasks inspired by Kara Walker and Damien Hirst. Learn how to effectively use light like Johannes Vermeer and master perspective like Piero della Francesca.

Using this book you'll experience a huge variety of techniques favoured by the Greats and understand their processes. Spanning several centuries, from today's vibrant contemporary art world to the ever-magical Renaissance period, this broad, fun and creative analysis of art, with authentic tuition, will enlighten you about incredible art history, how exactly art has evolved both technically and conceptually, and how it's used powerfully and effectively to address issues in society such as race, gender or the environment.

Once you've completed the activities in this book you'll be more creative than you've ever been before. All the skills you'll acquire will provide you with new artistic approaches and the confidence to try anything. Maybe this book will inspire you to turn a corner of your home, or even the garden shed, into your studio space. The truth is you can be an artist.

Whether you're an art fan or simply seeking a moment to unwind, this book has something for everyone.

A. J. ADAMS

HOW TO USE THIS BOOK

Don't wear your finest suit while undertaking these activities. I know Basquiat wore Armani when he painted but hold off until you find your art dealer.

Find somewhere suitable to do these activities (avoid your mother's best tablecloth). Prep all areas (art materials have a mind of their own).

Read a little – I've given you the low-down on each of the Greats. Knowing a bit about them will help inspire you before you attack the pages.

I've aimed to keep this book purely artistic and fun so there's no text overload. But, I urge you, good reader, to seek references elsewhere such as the internet to feed your imagination.

If you aren't sure about something, please refer to my blog (amyjaneadams.co.uk) and Instagram page (@artful_of_history), where you can witness my own attempts at these activities.

Improvise – perhaps I've asked you to use a certain medium and you don't have it. That's fine, use the next best thing available to you. Don't worry about 'getting something wrong', there's no such thing. Approach each activity with gusto and an open mind – this is about art, after all.

Warning: Contains occasional humour.

WHAT YOU WILL NEED

Paintbrush

Pastels

Paint

Rubber gloves

Props

A glass

Watercolours

Graphite pencil

Modelling balloons

Crayons

Masking fluid

Water

Paper

Marker pen

Black ink

Paperclip

Printer

Ruler

Hairspray

Eraser

Sharpener

Charcoal

Phone

Scissors

Something to mix paint on

Glue

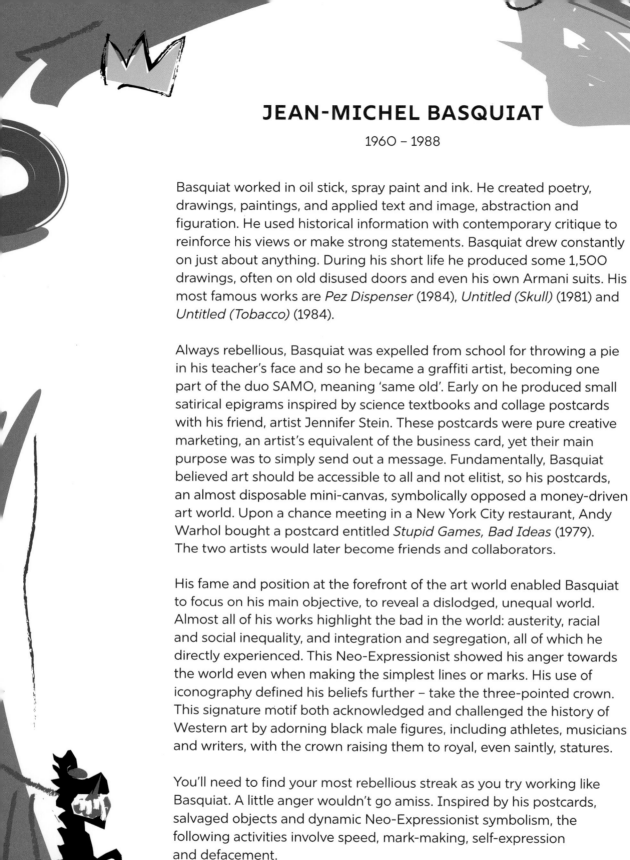

JEAN-MICHEL BASQUIAT

1960 – 1988

Basquiat worked in oil stick, spray paint and ink. He created poetry, drawings, paintings, and applied text and image, abstraction and figuration. He used historical information with contemporary critique to reinforce his views or make strong statements. Basquiat drew constantly on just about anything. During his short life he produced some 1,500 drawings, often on old disused doors and even his own Armani suits. His most famous works are *Pez Dispenser* (1984), *Untitled (Skull)* (1981) and *Untitled (Tobacco)* (1984).

Always rebellious, Basquiat was expelled from school for throwing a pie in his teacher's face and so he became a graffiti artist, becoming one part of the duo SAMO, meaning 'same old'. Early on he produced small satirical epigrams inspired by science textbooks and collage postcards with his friend, artist Jennifer Stein. These postcards were pure creative marketing, an artist's equivalent of the business card, yet their main purpose was to simply send out a message. Fundamentally, Basquiat believed art should be accessible to all and not elitist, so his postcards, an almost disposable mini-canvas, symbolically opposed a money-driven art world. Upon a chance meeting in a New York City restaurant, Andy Warhol bought a postcard entitled *Stupid Games, Bad Ideas* (1979). The two artists would later become friends and collaborators.

His fame and position at the forefront of the art world enabled Basquiat to focus on his main objective, to reveal a dislodged, unequal world. Almost all of his works highlight the bad in the world: austerity, racial and social inequality, and integration and segregation, all of which he directly experienced. This Neo-Expressionist showed his anger towards the world even when making the simplest lines or marks. His use of iconography defined his beliefs further – take the three-pointed crown. This signature motif both acknowledged and challenged the history of Western art by adorning black male figures, including athletes, musicians and writers, with the crown raising them to royal, even saintly, statures.

You'll need to find your most rebellious streak as you try working like Basquiat. A little anger wouldn't go amiss. Inspired by his postcards, salvaged objects and dynamic Neo-Expressionist symbolism, the following activities involve speed, mark-making, self-expression and defacement.

Express yourself like Basquiat. Look for scratches and marks on surfaces and record them in oil pastels all over this page.

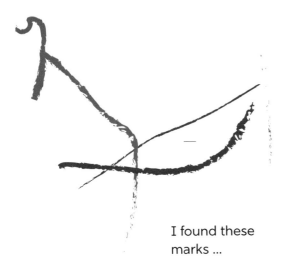

I found these marks ...

Basquiat used rapid, uncontrived and spontaneous marks. This expressive approach evokes anger and unrest. He reinforced the mood of his work further when he used damaged surfaces as his canvases.

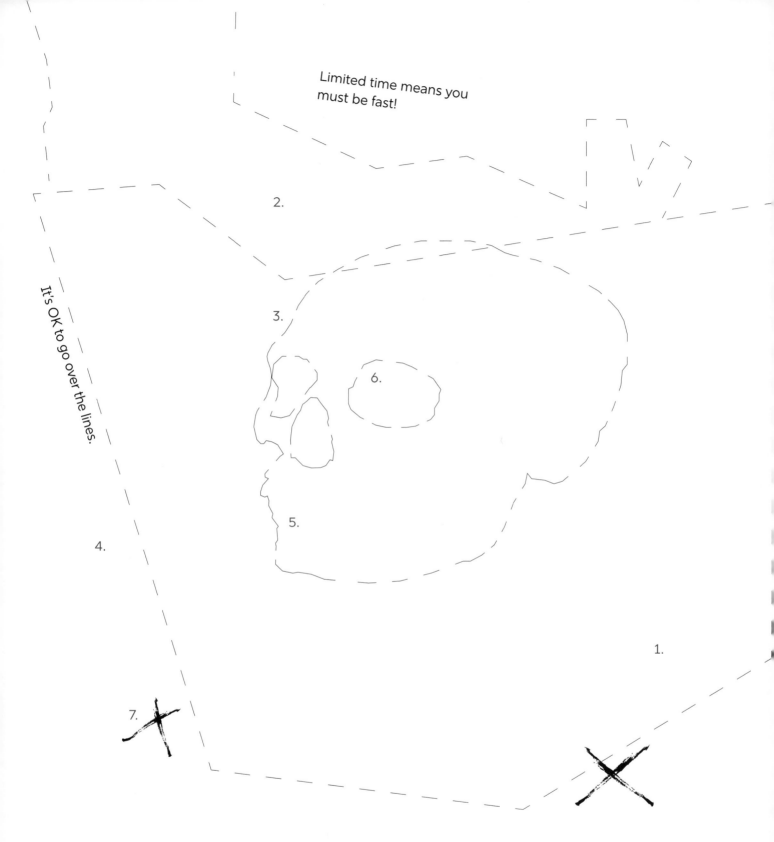

Limited time means you must be fast!

2.

It's OK to go over the lines.

3.

6.

5.

4.

1.

7.

Use oil pastels. Be rough and vigorous. Follow the instructions in numerical order and complete in the time stated. **1.** Colour this large area blue (8 secs). **2.** Colour this area yellow and draw a crown on the skull (12 secs). **3.** Outline the skull including the eyes and nose (5 secs). Do this twice, firstly in red, then black. **4.** Colour the outside area green (8 secs). **5.** Draw a square mouth (2 secs). **6.** Colour the eyes red and add eyelids in blue (6 secs). **7.** Sign your name between the crosses (2 secs).

Draw words, letters,
numbers, logos, fried eggs
and statements about the
world on these objects. Use
coloured crayons and ink.

If Basquiat's dinosaur could shout at the culprit for its extinction, a meteorite, what would it say? Let the dinosaur exclaim his thoughts using these speech bubbles.

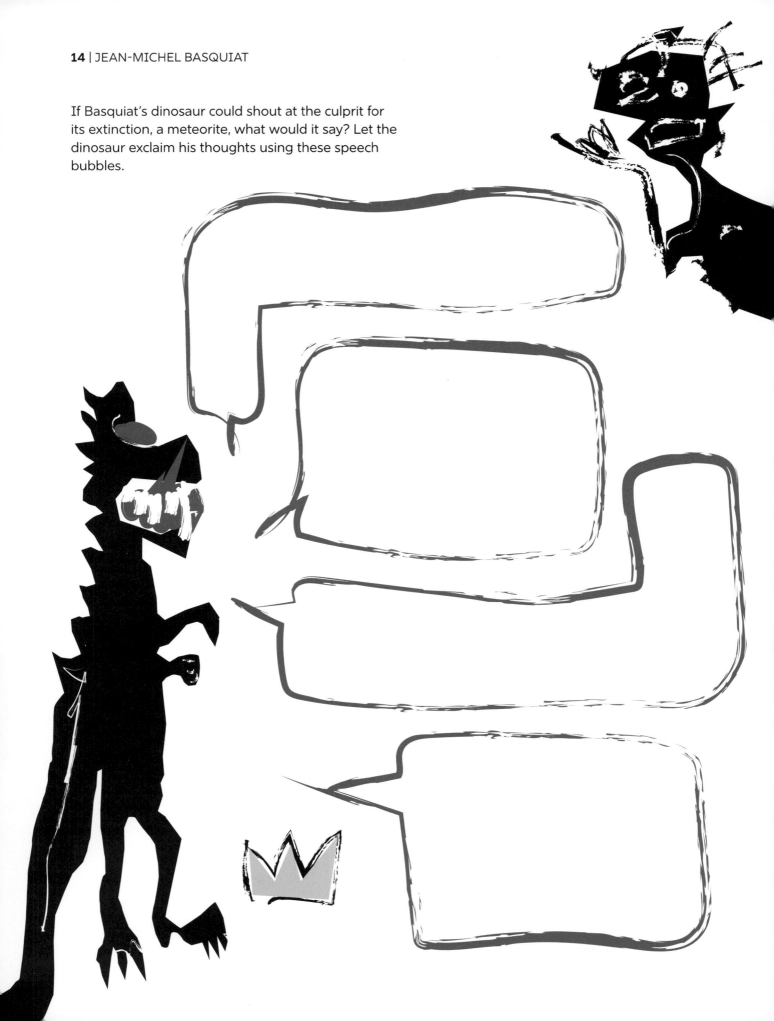

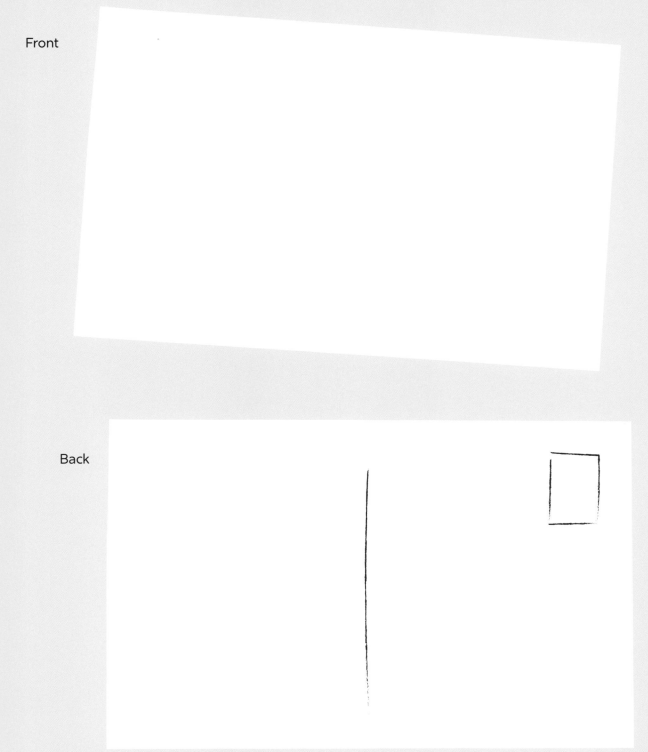

Front

Back

Inspired by Basquiat's postcards, create your own. Make your feelings on money in society loud and clear. Austerity, inequality, poverty, homelessness, emotional and physical wellbeing or billionaires, whatever it is you feel is unjustified write it bold on the front. Include a collage made of sweet wrappers, torn-out letters from newspapers, ink splats and images related to your statement. Explain your statement on the back. Address it to someone who might benefit from reading it.

HIERONYMUS BOSCH

c. 1450 – 1516

Hieronymus Bosch was a painter of fantastical worlds where hybrid animals, dreams, fears, ugliness and beauty coexisted. Bosch came from a family of artists. His grandfather, father and three uncles were also painters. He worked in oil paint, depicting densely filled scenes of a religious ideal or everyday life. Only a few of his works survive and, unlike other artists featured in this book, little is known about his thoughts or intentions.

His most famous work is *The Garden of Earthly Delights* (1495–1505). This rich, fantastical scene was designed to entertain, with men depicted enjoying a siesta inside a mussel shell and bouquets protruding from derrières. Remarkably, this eye-witness commentary of the world, albeit with a touch of flagrant mockery, forms part of a deeply serious religious scene.

Bosch grew up in a devoutly religious community in the Netherlands, which had a fascination with humanity's desires and deepest fears. The artist was schooled by the Christian church in his hometown of 's-Hertogenbosch where at the time, like much of northern Europe, there was a real emphasis on 'heaven' versus 'hell'. His work is heavily influenced by this mindset. He was also fascinated by humanity, diversity and people of all walks of life, showcasing the most grotesque to the gracious and well-respected of society. There is nothing judgemental in his depictions. He does demonstrate a very good sense of humour though, through his ability to exaggerate human behaviours and characteristics. He even went one step further and designed his own hybrid creatures, a mix of both humans and animals, which provided sheer entertainment for the viewer.

Just like Bosch, you'll be encouraged to alter and surprise with the creation of your very own hybrid creatures, including one inspired by your objects at home. Recreate an avian detail found in *The Garden of Earthly Delights*. Explore the meaning of good and bad by illustrating everything you consider to be in your heaven and hell, a recurring theme in the artist's works.

Recreate these creatures
Bosch liked to alter and make
unrealistic.

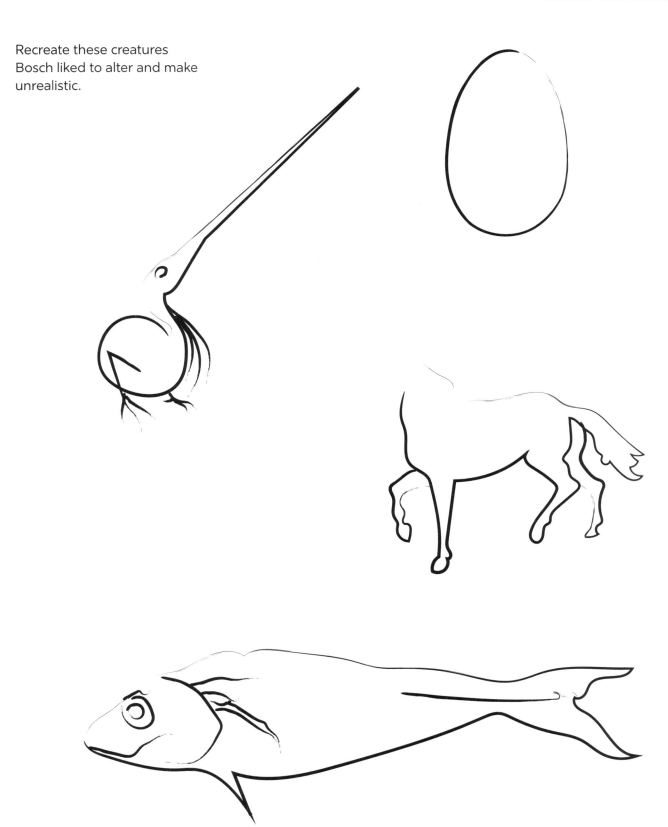

1. Give the egg some feet. **2.** Depict the long beak of the bird impaling a strawberry.
3. Give the horse a chicken's head. **4.** Depict someone riding the fish.

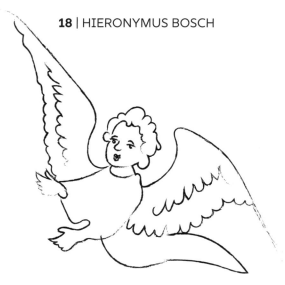

Fill the top half of this spread with everything in your heaven and the bottom half with everything in your hell. Doodle it all using a black ink pen. Colour them in. You must keep things small because the aim is to densely fill the scene.

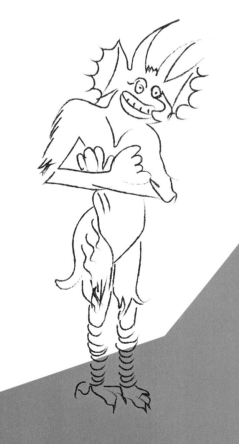

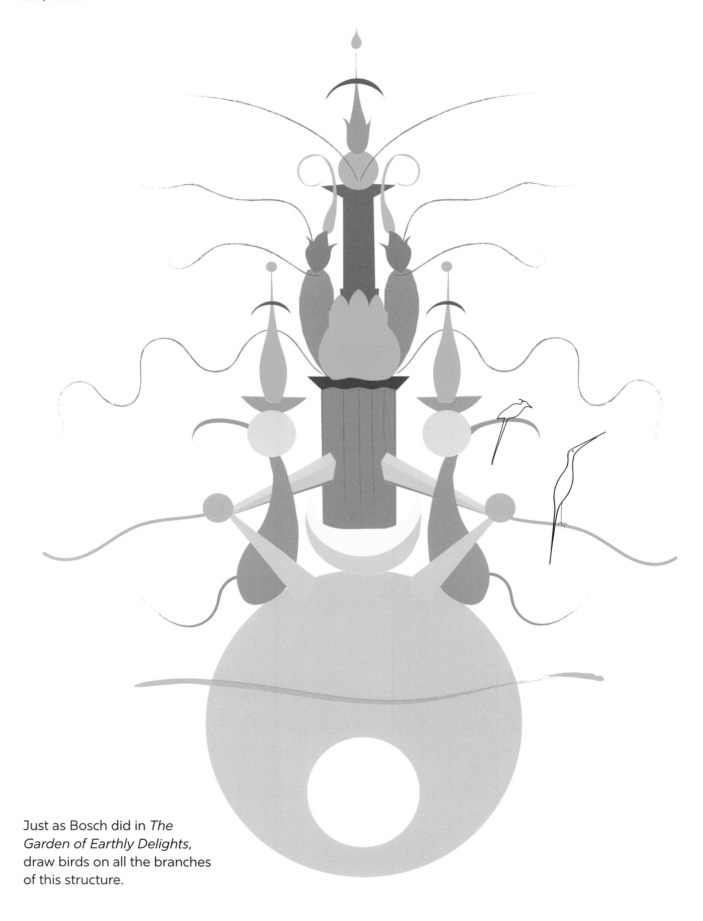

Just as Bosch did in *The Garden of Earthly Delights*, draw birds on all the branches of this structure.

Head

Arms

Chest

Stomach

Groin

Legs

Feet

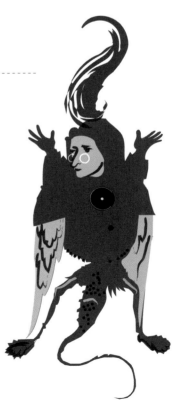

Create a hybrid creature, as Bosch did of himself (right).
He put a cauldron on his head, wings for arms and insect legs. Draw your
hybrid head first and then replace other parts of your body with six things
found in your home, including pets, electricals – anything you want!

DANIEL BUREN

1938 –

Daniel Buren is a French conceptual artist, painter and sculptor. Shapes and alternating coloured and white stripes define his mostly site-specific work. There's nowhere Buren won't stripe. All of his works are created in situ, totally transforming spaces and historical architecture, leading viewers to question how we look and perceive, how spaces can be maximized and utilized.

Most famously he created *Les Deux Plateaux* (1985) in the Cour d'honneur of the Palais-Royal in Paris. More commonly known as *Colonnes de Buren*, this installation features black and white striped marble columns of different heights. The work replaced a former car park and was designed to conceal ventilation shafts for an underground extension of the culture ministry's premises. He also transformed the Observatory of Light in the Fondation Louis Vuitton, giving the observatory a canopy of glass made from over three thousand panels resembling ships' sails.

Buren's site-specific works are referred to as 'interventions', whereby he applies his stripes to public spaces or objects. He is essentially a graffiti artist who has been granted permission to dazzle passersby with his striking 'defacement' of a location. Buren did in fact start out as a street artist, defacing walls, structures and billboards on the streets of 1960s Paris. Preferring to join the art world, he would consciously make his public art thought-provoking and collaborate with other artists and leading institutions. For an exhibition at the Art Institute of Chicago in 1980, Buren striped the doors of several public trains. The Institute is next door to a railway station and visitors to the gallery, looking through a window, were informed when Buren's striped trains were scheduled to stop on the platform they could see, via the simple title of the work, *Watch the doors, please!* and a 'Buren timetable' on the wall.

You won't be encouraged to make an intervention at your nearest heritage site in these Buren activities. Instead, you'll have to stay within the confines of the pages of this book. Practise the art of precision à la Buren and draw alternating coloured stripes (it's much harder than you might think) and refine your execution while you work with repetition. Transform world-famous landmarks with stripes. Realize the playfulness of even the most simple shapes and forms using various angles and proportions on the page.

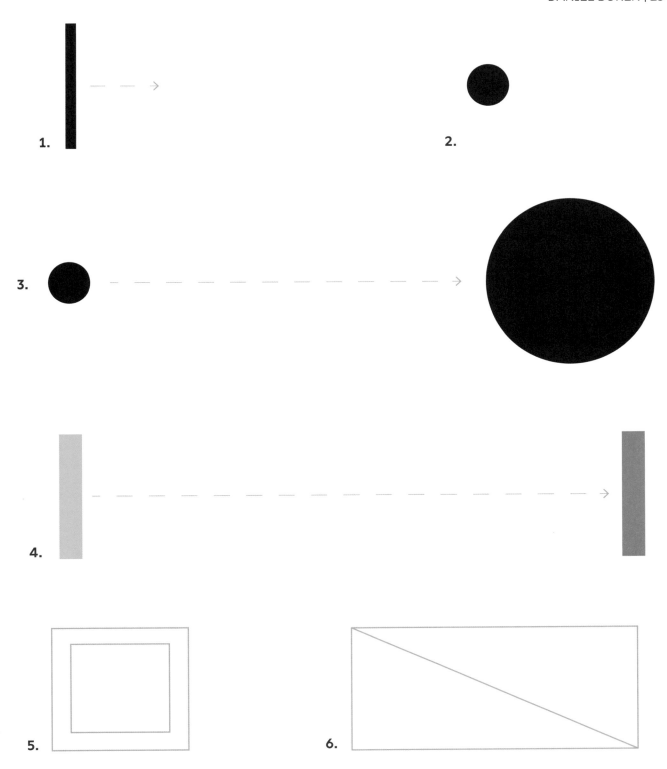

1. Repeat this line 3 times. They should be equal in length and width. **2.** Circle this circle 5 times gradually scaling-up as you go. **3.** This small circle is your starting point. Draw 3 more on the dotted line gradually increasing in size until you meet the large one. **4.** Repeat the line until you come to the red one. Your spacing should be equal to the width of the line. **5.** Stripe the border of this square. **6.** Stripe the left side of this box horizontally and the opposite side vertically.

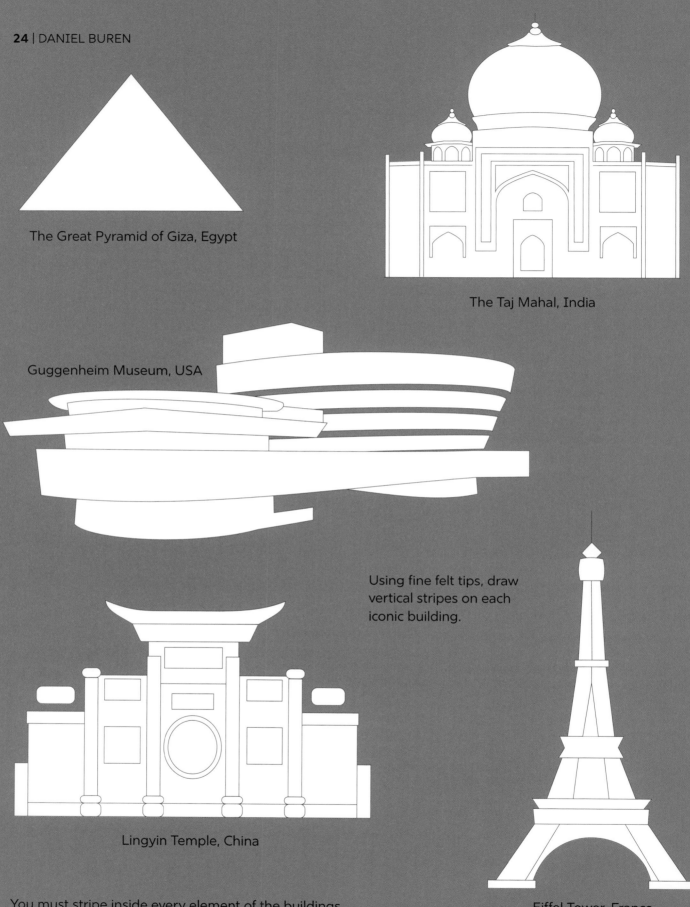

The Great Pyramid of Giza, Egypt

The Taj Mahal, India

Guggenheim Museum, USA

Using fine felt tips, draw vertical stripes on each iconic building.

Lingyin Temple, China

Eiffel Tower, France

You must stripe inside every element of the buildings and stay within the lines.

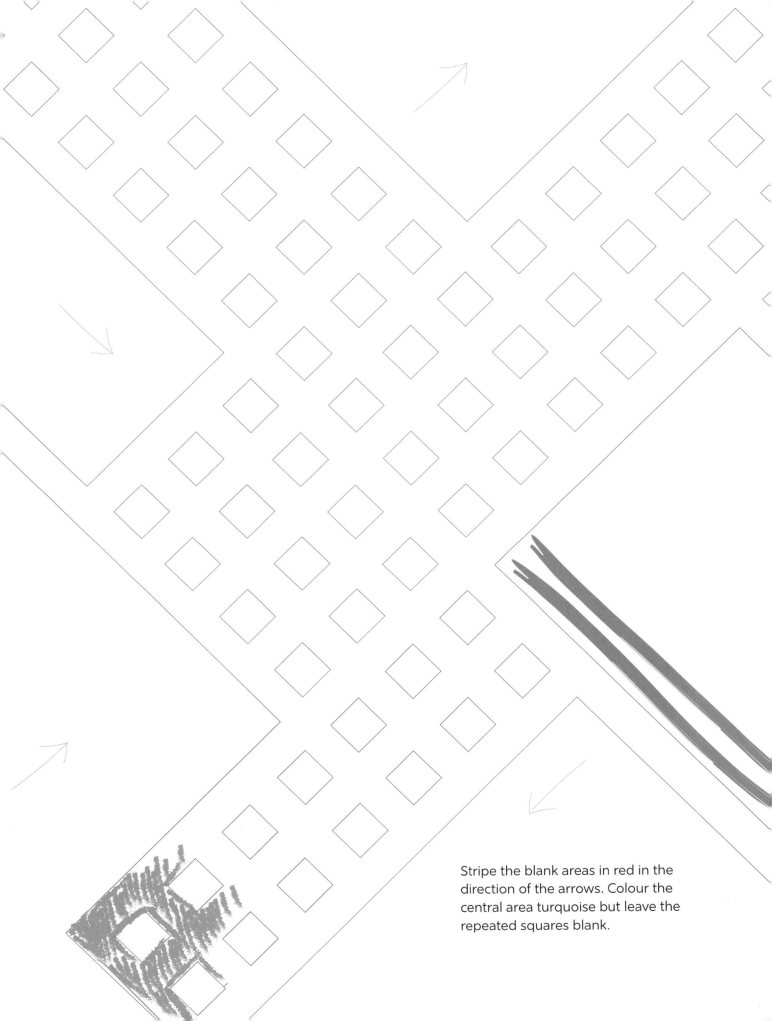

Stripe the blank areas in red in the direction of the arrows. Colour the central area turquoise but leave the repeated squares blank.

Fill the sections with either vertical or horizontal stripes, checks or circles. Don't mix them within a section. Use a different colour for each. Keep each pattern separate.

SALVADOR DALÍ

1904 – 1989

Dalí was a painter, performance artist, filmmaker, designer and eccentric self-promoter. Undoubtedly he remains the most significant surrealist artist ever. He created dreamlike scenes and was interested in the subconscious mind.

His most famous works are *The Persistence of Memory* (1931), a dreamscape featuring limp, melting gold watch faces crawled on by an army of ants in a desert land. *Dream Caused by the Flight of a Bee Around a Pomegranate One Second Before Awakening* (c. 1944) is another landscape, but this time featuring a woman said to represent his manager and wife Gala. Droplets of water and a pomegranate symbolize fertility and resurrection. Above the fruit flies a bee, the symbol of the virgin. A Yelloweye Rockfish flies through the air. A tiger leaps ahead which in turn projects another from out of its jaws. The work also features a rifle, bayonet and the first of Dalí's iconic elephants with flamingo legs. Dalí was deeply fascinated by the work of psychologist Sigmund Freud and adopted Freud's theories in order to further present a divide between dreams and reality. He later said this work represented Freud's discovery of the typical dream. Other famous works are *The Temptation of St Anthony* (1946), and *Lobster Telephone* (1936).

Dalí believed life was too short to go unnoticed, so he left his hometown of Figueres, Spain in 1926 at the age of twenty-two and moved to Paris. He soon joined the Parisian Surrealist group founded by André Breton, becoming one if its most influential members until his expulsion in the late 1930s. Luckily, Dalí continued on his surrealist journey for the next thirty years, shocking and mesmerizing viewers with unique scenes made up of precise draftsmanship, idiosyncratic iconography such as rotting donkeys and dismembered bodies, and lighting and landscapes strongly evocative of his native Catalonia.

Unearth all your wildest dreams while exploring these Dalí activities. Make everything surreal and create surprise. Be ridiculous, starting with taking his iconic moustache on a journey across the page. Make objects and imagery in reality into a fantasy and stir amusement. Record your dreams and compile them all into a final work of art.

Dalí's moustache is as iconic as his work.
Take it on a mad journey up and down,
round and around, criss-crossing, sliding to
the left, sliding to the right!

Dalí's art divided opinion and reality in equal measure. His surrealist landscapes inspired by his native Spain contain dreamlike scenes filled with opposing characters. Make these real characters surreal.

Give these wings to a mammal.

Make this nose the front of a vehicle.

Turn this moon into something else that's round.

Put something inedible on this fork.

Draw something botanical on the top lip.

DREAM JOURNAL

Complete this dream journal. Your dreams are most vivid when you first wake, so keep it next to your bed so it's easily accessible. Note down anything you can possibly remember, including where you were and who you were with, what you could see, hear and how you felt emotionally. Include good and bad things.

MONDAY

TUESDAY

WEDNESDAY

THURSDAY

FRIDAY

SATURDAY/ SUNDAY

Now, just like Dalí, illustrate your week of dreams here. You should compile the events, experiences and encounters you had in your sleep, creating a dreamlike world.

PIERO DELLA FRANCESCA

c. 1415 – 1492

Piero della Francesca was an Early Renaissance Italian painter. He was the master of perspective and geometric forms, which characterized the composition of all his work. He combined his unique skill as a mathematician with his artistic ability to become a painter of realism, which resulted in some of the most beautiful imagery of the fifteenth century. His delicate colour palette provides an ethereal look, working in harmony with thought-provoking religious ideals.

Piero's most famous works include *The Baptism of Christ* (*c.* 1450), an image of Christ being baptized in the River Jordan by John the Baptist. Technically, this striking composition is comprised of a simple semicircle sitting on a square. If a sketch of an equilateral triangle with the tip pointing down were drawn in the square, it would meet the toes of Christ's engaged leg. Christ's folded hands are positioned in the centre of the triangle and the centre of the base line is marked by the dove above his head. This is a technique used also by Leonardo da Vinci, which you will explore. Later, the artist created *The Resurrection* (1460s). This fresco was created for the Palazzo della Residenza in the town of Sansepolcro, Tuscany, Italy. Jesus, a pillar of strength standing tall with one foot on his tombstone, is depicted in the centre of the composition in the moment of his resurrection. Beneath him lie four soldiers who, in contrast, lie exhausted post-battle. Legend has it that the figure to the right of Christ in brown armour is the artist. This idealized image speaks of Christ's light defeating death. Its composition is unusual because it contains two vanishing points, one at the centre of the faces of the figures seated on the grass in the foreground, and secondly Christ's face.

Understand perspective and the importance of the vanishing point – it dictates *everything* when the artist creates a scene. Learn to manipulate your perspective and alter what you see. Try simple geometry and use it to create precise patterns.

This linear perspective with parallel lines gives the illusion that the patterns are disappearing, hence the term vanishing point.

Repeat these patterns until the lines appear to meet the sun. This is the vanishing point.

Divide this circle four times. The marks
on the edge of the page are your
guide. Use a pencil and ruler.

Just like this ...

Colour in the sections using
crayons and alternate in
blue and yellow.

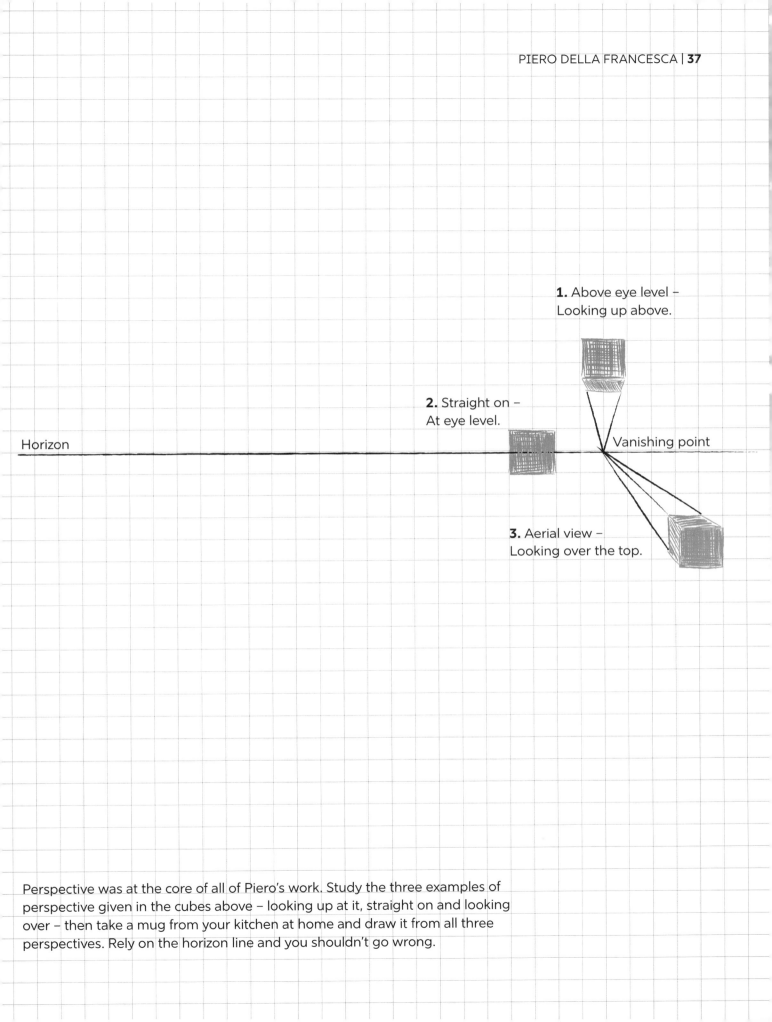

1. Above eye level –
Looking up above.

2. Straight on –
At eye level.

Horizon — Vanishing point

3. Aerial view –
Looking over the top.

Perspective was at the core of all of Piero's work. Study the three examples of perspective given in the cubes above – looking up at it, straight on and looking over – then take a mug from your kitchen at home and draw it from all three perspectives. Rely on the horizon line and you shouldn't go wrong.

Use watercolour and crayons to create other trees like the one below. Their positions are marked out using dotted lines. They are sized differently depending on their position in the fore- or background. Adding the foliage will help you understand visual perspective.

TOP

BOTTOM

LEONARDO DA VINCI

1452 – 1519

Leonardo da Vinci was a painter, draughtsman, engineer, scientist, sculptor and architect. Da Vinci was multi-talented but he wasn't prolific – he would often half-finish things. But that didn't stop him becoming one of the world's most iconic artists. His most famous work is the *Mona Lisa* (1503–6). This half-length portrait is composed of oil on wood and is believed to depict Italian noblewoman Lisa del Giocondo. Softly depicted, Mona is not classically beautiful yet she appears warm and enigmatic. Her smile is legendary. Da Vinci also painted *The Last Supper* (1495–8), a fresco created for the Convent of Santa Maria delle Grazie in Milan, Italy. The Christian scene depicts Christ and his disciples sharing a final meal.

During his lifetime da Vinci's painting practice also coincided with an engineering career. He developed technical drawing and 'exploded' diagrams of his designs, logging some five thousand pages of them. It wasn't until long after his death that his notebooks – filled with incredible inventions and scientific discoveries – were found. If these had been published during his lifetime, he most definitely would have been hailed as a genius. In death, he is certainly celebrated as one. Deeply fascinated by the idea of flight, his inventions included a helicopter and other flying machines.

Da Vinci's work has a softness to it because he didn't apply an outline to his depictions; instead he blended his images into the background and foreground. This technique was known as sfumato. This gave his works, including *Mona Lisa,* a distinctive style unlike any other Renaissance artist. You will try this technique for yourself. Experiment with Mona Lisa's smile and alter her mood for fun. Was she really smiling? You work it out. You'll be guided on how to draw the ideal human body comprising of accurate proportions based on da Vinci's *Vitruvian Man* (*c.* 1490) and follow the drapery and folds of Renaissance garments. Draw like Leonardo and acquire various shading techniques.

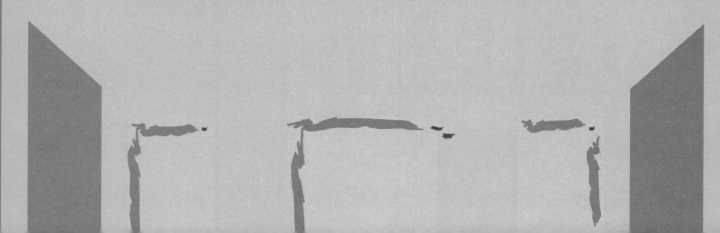

Sad Mona

Shocked Mona

Annoyed Mona

Mischievous Mona

Angry Mona

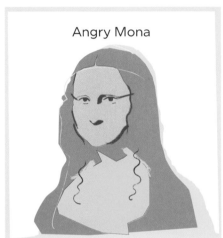

Happy Mona

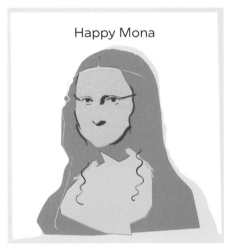

Romantic Mona

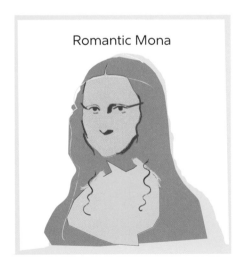

Sleepy Mona

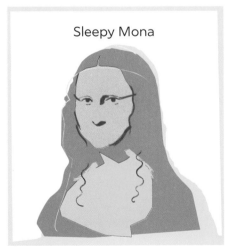

Scared Mona

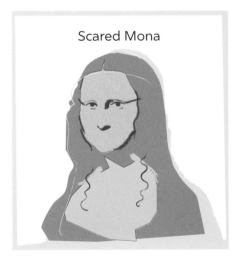

Da Vinci's *Mona Lisa* is famous for her enigmatic smile. It's now your turn to play with her expression. Draw Mona's mouth according to how she feels. This is harder than it looks. It's a great idea to look at your own mouth in the mirror while you act out the different expressions.

This activity is based on da Vinci's *Vitruvian Man*, a drawing of the ideal human body proportions representing the close relationship of mathematics and art.

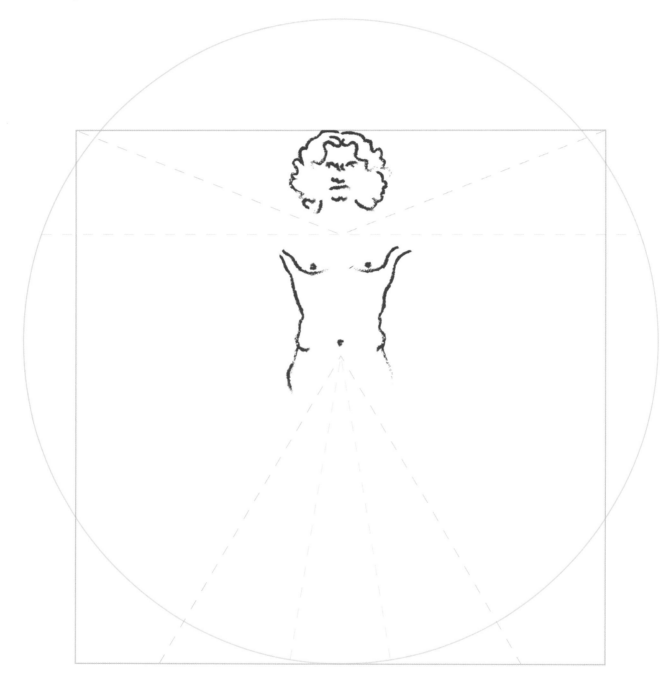

Complete Leonardo's figure. Draw two pairs of arms and legs, one inside the circle and the other inside the square. The positions of the limbs should correspond with the lines provided. Both sets of limbs must retain exactly the same proportions, with the fingertips and feet touching the edge of the shapes.

One of the first things da Vinci trained to draw was drapery, creating detailed drawings of creases, pleats and folds. Using a red crayon, draw pinstripes on the fabric. The folds determine the direction of your stripes.

I've started some here ...

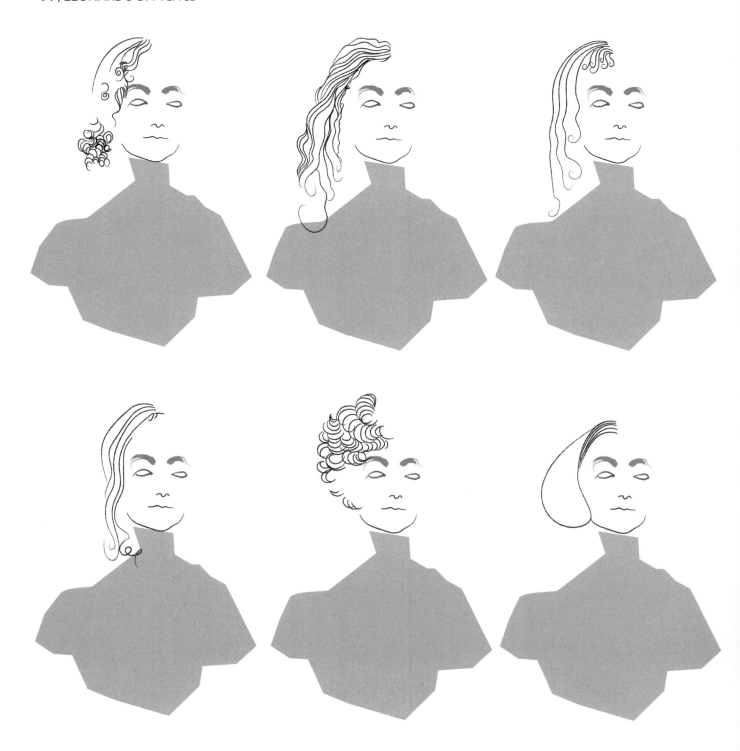

Complete the other side of these Renaissance
hairstyles using black ink. Hair in reality is soft and
blows in the wind – draw delicately, as if you were
stroking someone's hair.

Fill the shadows using hatching, cross hatching or curved hatching. Use hatching when a shadow is largest, as in reality it would appear less dark. Use curved hatching for rounded objects and cross hatching for shorter shadows that in reality would be darkest.

Hatching

Cross hatching

Curved hatching

Like this ...

Trees

Leonardo used sfumato, a painting technique that softens the clashing of two colours. These scenes consist of two colours. Apply a colour found in between the subject and the background colour. Use soft pastels and rub them with your fingers, creating a gentle transition of colour typical of the sfumato effect.

Mountains

Clouds

Like this ...

Flowers

KEITH HARING

1958 – 1990

Keith Haring was a pop artist who began his art career drawing on walls and advertising posters in the New York subway. He was also an animator, set designer and philanthropist. He was inspired to draw at a young age by his father, an amateur cartoonist, and by Disney cartoons.

His most famous works are *Crack is Wack* (1986), a mural in New York warning against the use of crack cocaine and *Radiant Baby* (1990), which symbolized the purest and most positive experience of human existence. He opened his Pop Shop store in New York City and Tokyo in 1986. Haring viewed the shop as an extension to his work. He believed his work ought to be accessible to everyone and not just restricted to gallery walls: he wanted children to have access to it as well as collectors. He drew his distinctive imagery all over the walls of the shop, making a completely immersive experience for visitors.

Haring's art was simply a voice to communicate strong social messages covering universal subjects including birth, death, race, sex, war and AIDS. His style was distinguished by a direct use of line with uncomplicated imagery, resulting in a clear, concise message. Most of his work was playful and childlike in its execution, instantly engaging the viewer and getting his message across.

You will explore Haring's use of continuous lines, the human figure and how to animate it using the simplest techniques, including his iconic radiating lines. Embrace your playful side as you complete Haring-style scenes composed of human behaviours and circumstances.

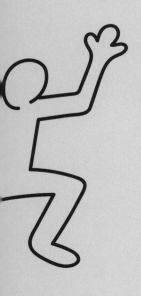

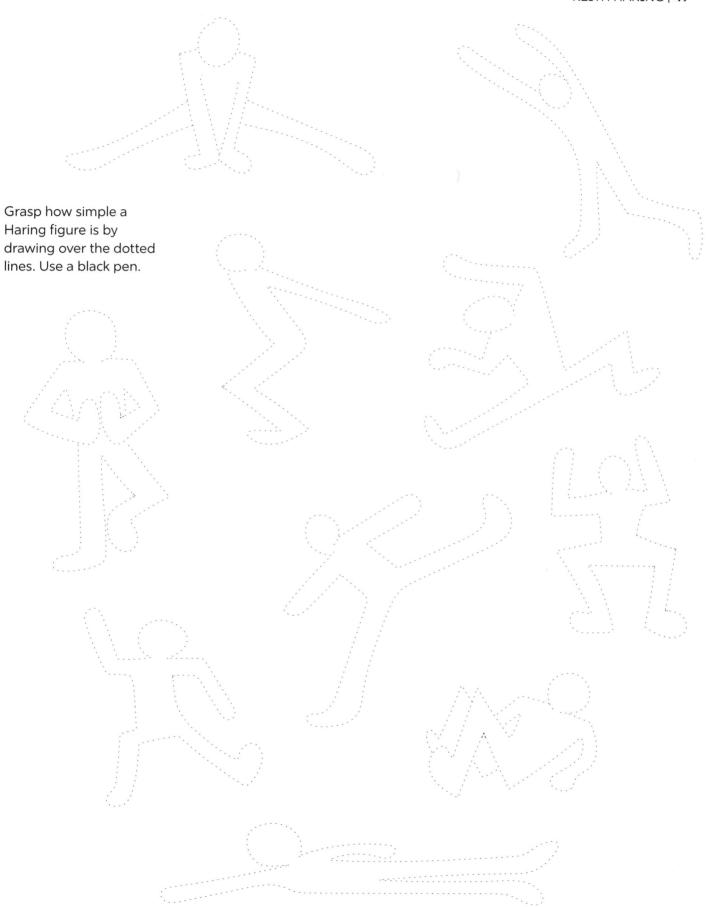

Grasp how simple a
Haring figure is by
drawing over the dotted
lines. Use a black pen.

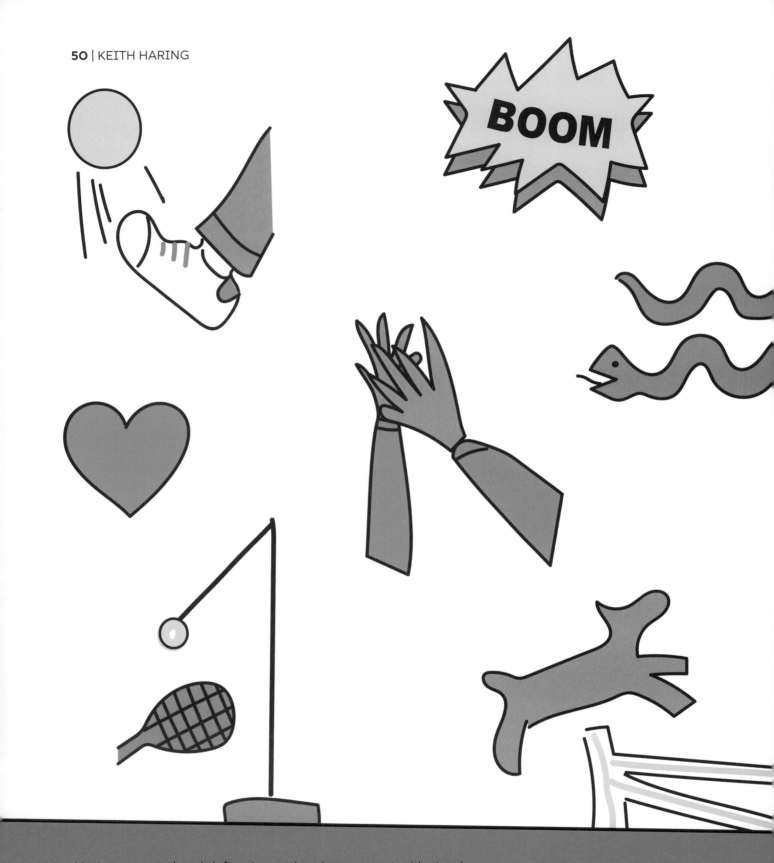

Haring captured and defined sound and movement with simple radiating lines. Take the man kicking the ball as an example – lines behind the ball imply its fast ascent into the air. Apply radiating lines to the rest of the images. Carefully consider the real-life sound or movement of each object or action.

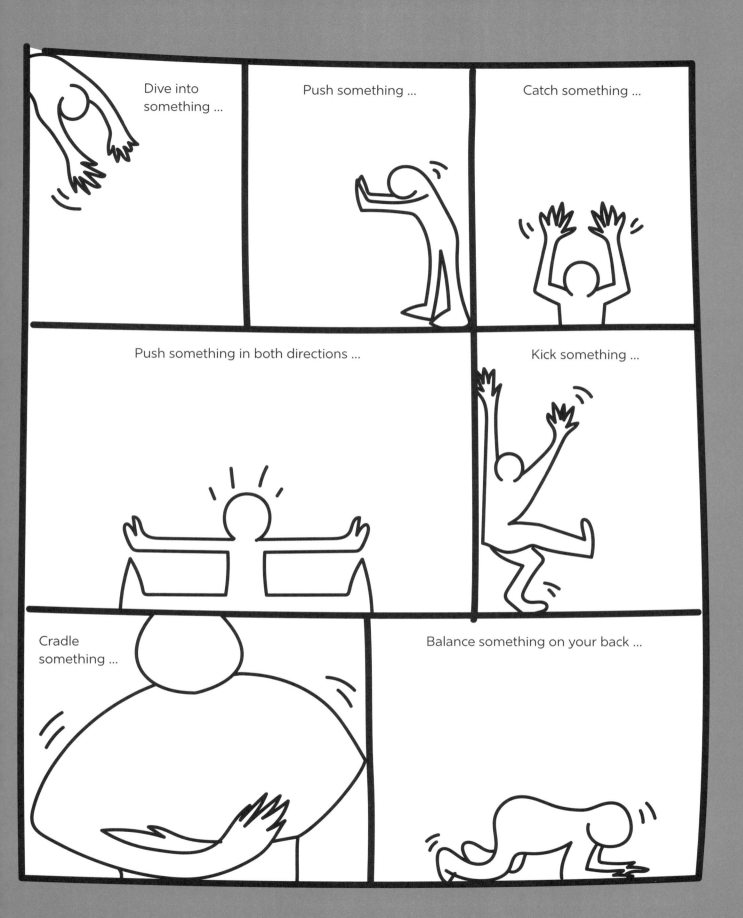

Complete each of these scenes by drawing in the missing detail.

Haring liked to highlight human interaction by depicting the same figure
multiple times, often linking them. Continue these chains of figures.

Now you've mastered a Haring figure,
draw a person walking this dog.

DAMIEN HIRST

1965 –

Damien Hirst creates paintings, sculptures, installations and drawings. He is one of the Young British Artists (YBAs) who shot to fame and dominated the London art scene in the 1990s.

Hirst was always a rebel and at school he achieved almost no qualifications. His mother could get him to do one thing, though, and that was to draw. At art college in London he was determined to create 'really bad art and get away with it.' He undertook a work placement at a mortuary, an experience that saw the beginning of the artist's long-time fascination with death.

His most famous works include the *Medicine Cabinets* (1988), two small shelving units filled with the empty packaging of his deceased grandmother's medication. Hirst's works explore the distinction between life and death, myth and medicine. One piece, *The Physical Impossibility of Death in the Mind of Someone Living* (1991), consists of a preserved tiger shark submerged in formaldehyde in a glass-panel display case. He has also preserved cows and sheep, and used butterflies in his work.

Aside from his installations, his 'spot' paintings are undoubtedly his most recognized works. Hirst considers this random and infinite colour series to be mathematical and an important discovery of harmony in art, showing how colour can exist on its own, while working with other colours. The spot series gave the artist a greater understanding of colour. He also creates 'spin' paintings such as *Beautiful career minded painting (with blue slash)* (1997). To make this work of art he stood on a ladder and poured household paint on a circular canvas that was being spun by a machine.

For many, Hirst's work can seem baffling or often be perceived as so simple that people retort, 'Anyone could do that!' You're going to explore the artist's code-like methods and straightforward way of thinking, his meticulous approach and playful use of colour. You, too, will gain a greater understanding of colour.

Paint spots similar to the ones on the opposite page. Use bright colours and only two dark colours, as Hirst does. Your colours must complement each other so consider your palette carefully.

Create a spin painting like Hirst: rotate this page while dripping watercolours or inks with a paint brush onto this circle. Use six colours. Hirst uses a spin machine so just do the best you can.

**HOLD THE BOOK
TIGHTLY HERE
AND SPIN!**

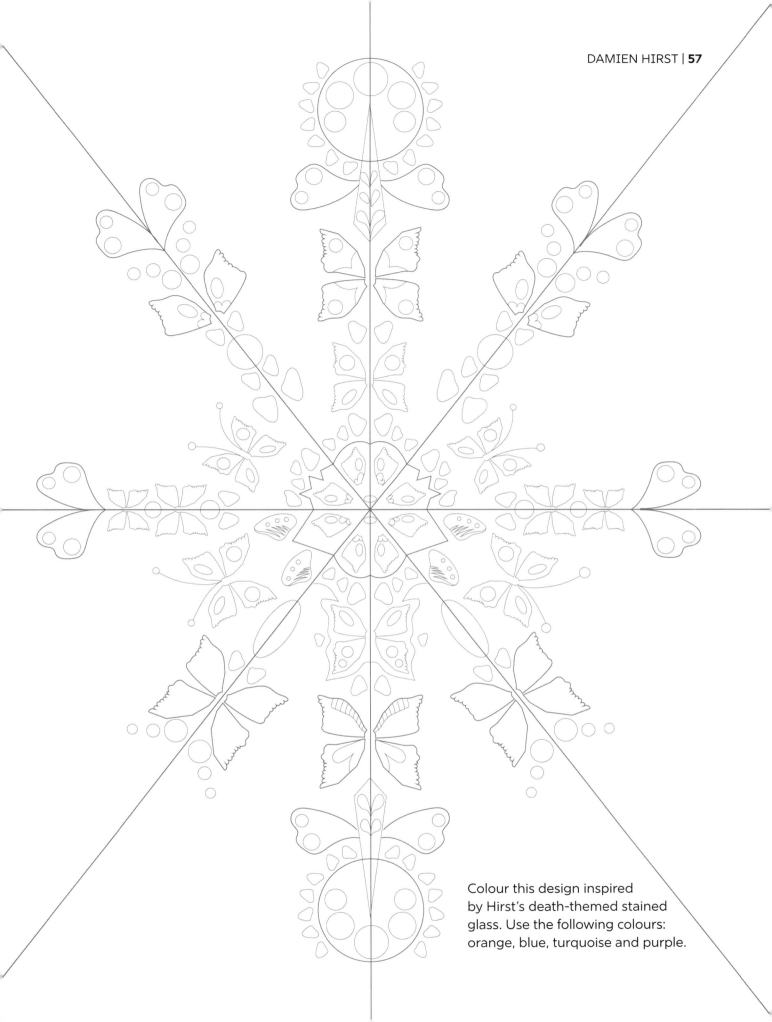

Colour this design inspired
by Hirst's death-themed stained
glass. Use the following colours:
orange, blue, turquoise and purple.

Hirst is fascinated by medicine and the influence it has on life and death. What we eat has a similar impact. Like medicine, humans can depend upon food too much and addiction is possible. What you eat can determine your lifespan. It's possible to eat yourself to death.

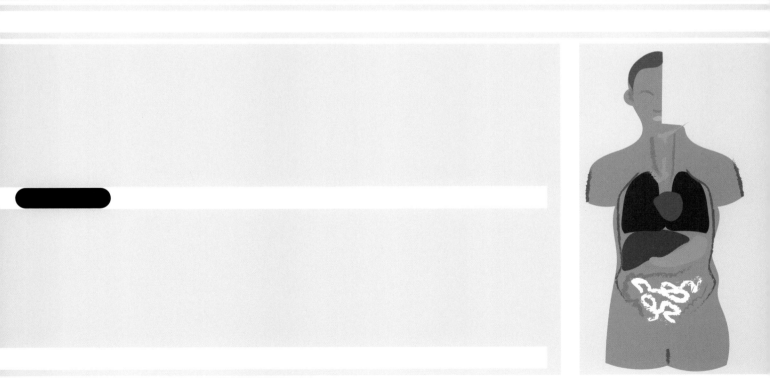

Collect labels from food packaging. Fix them according to the
colour-coded shelves. You can use a part of a label if it's too big.
Display as many as possible.

DAVID HOCKNEY

1937 –

David Hockney is a painter, printmaker, draughtsman, photographer and set designer. Hockney remains one of the twentieth century's most influential pop artists, whose use of colour and bold definition of the subjects he depicts means there is no mistaking his work.

In 1964 he moved to the Hollywood Hills, California, where he sought inspiration from the bright blue skies and laid-back lifestyle. While other pop artists were defining the era with all-consuming images of celebrities and advertising, Hockney chose to present a more stylish and understated corner of America. It was here where he created his most famous works, including *Portrait of an Artist (Pool with Two Figures)* (1972) and *A Bigger Splash* (1967). As the artist prepared to begin these new works, he started painting in acrylic rather than oil. Leaving behind the centuries-old medium, acrylic changed Hockney's work for ever. With acrylic drying notoriously quickly, Hockney had to work fast and his paint application had to be definite. As a result, his paintings appeared smoother and flatter, realistic yet simplified. Acrylic transported Hockney into modernity. The bright, playful Swimming Pool series would define the work of a young, inquisitive Hockney.

Since 2010 Hockney has adopted the Apple iPad as his medium, creating colourful digital landscapes on screen that are printed and exhibited often on a huge scale. The artist used the iPad to focus on how light behaves on materials such as glass. He even designed a window for Westminster Abbey, London, on the tablet.

Explore painterly marks used by Hockney to define environments as he made the transition from oil to acrylic. Boldly decorate a still life using colour and surface pattern, and apply shadow in order to create a stark contrast between light and shade.

Practise these marks. Try out each one first. Then, mix and match –
make them all dance around the page. It's up to you when it comes
to your layout. Be random or create unified patterns.

Give this still life surface pattern and texture using the various marks you see on the rug. Use crayons.

Use crayons to draw an eight-o'clock-shadow on these objects. Use a contrasting colour for each.

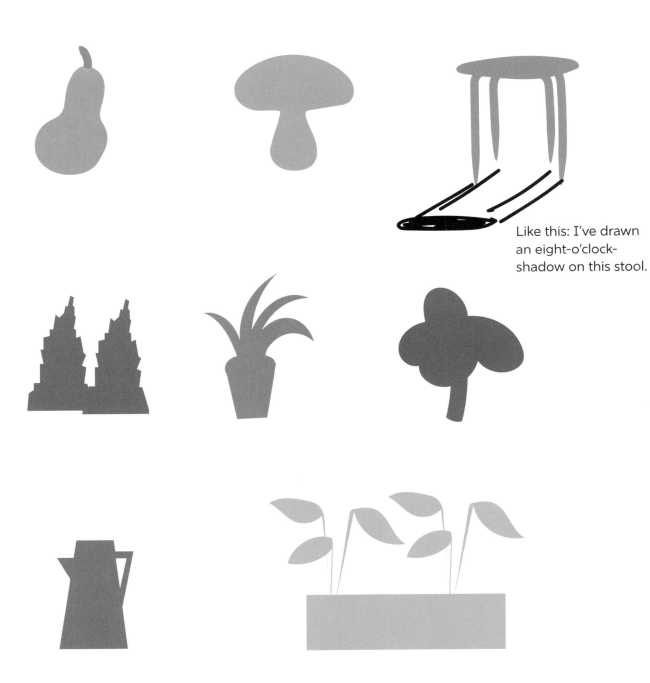

Like this: I've drawn an eight-o'clock-shadow on this stool.

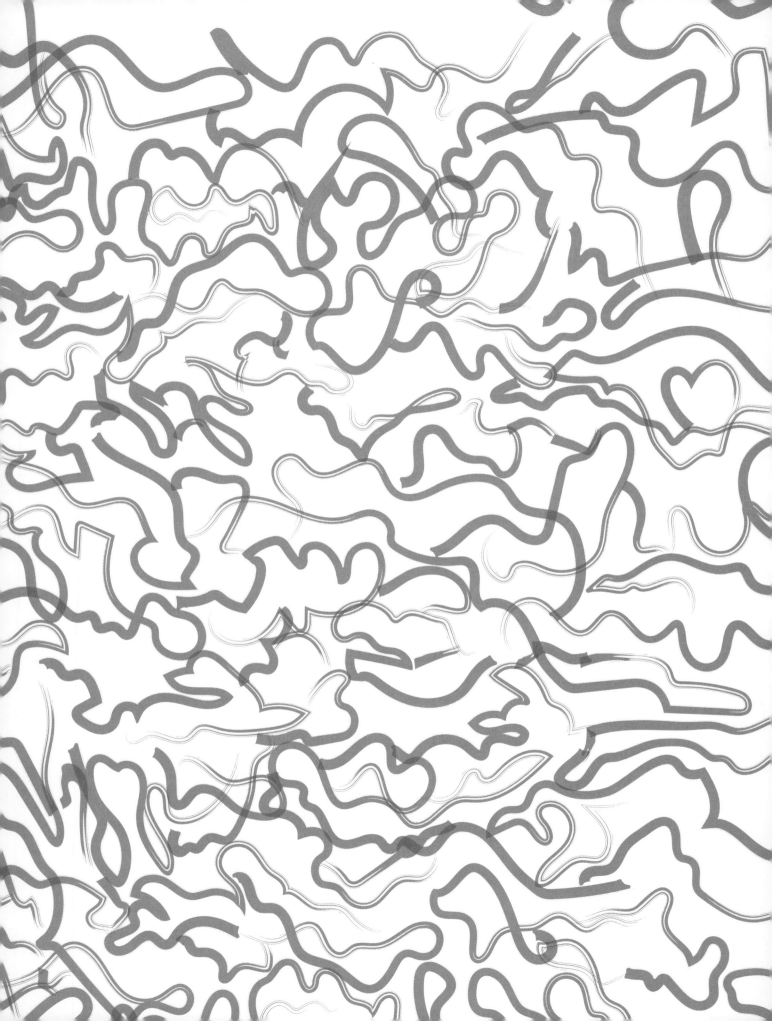

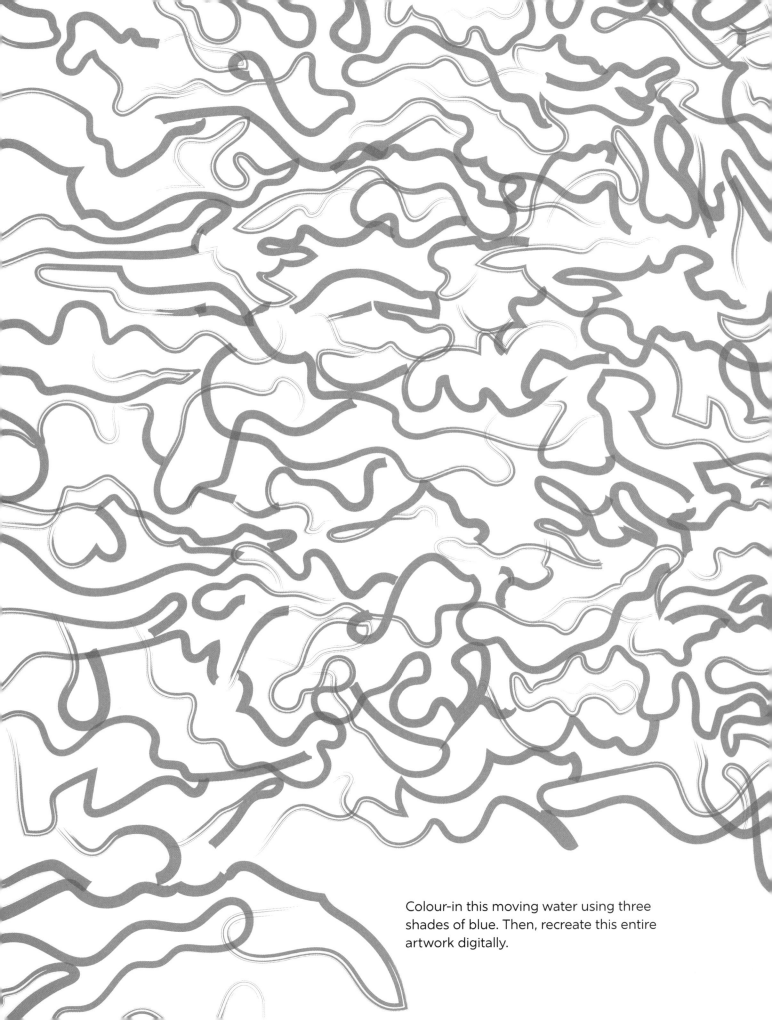

Colour-in this moving water using three shades of blue. Then, recreate this entire artwork digitally.

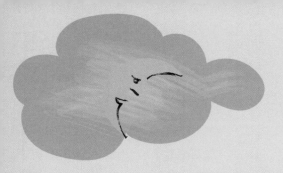

FRIDA KAHLO

1907 – 1954

Frida Kahlo was a painter. Today, she is also hailed as a feminist and LGBTQ+ icon, celebrated for her unique style. She created self-portraits wearing traditional Mexican textiles that would go on to make her fashion designer Elsa Schiaparelli's muse. Her autobiographical works addressed her disabilty (she suffered a terrible accident and endured a lifetime of chronic pain) and infertility. She also created scenes inspired by nature and her native Mexico.

Kahlo was most famous for her extensive series of self-portraits including *Self-Portrait with Thorn Necklace and Hummingbird* (1940). The work was painted at an unhappy time, just after her divorce and just as a new relationship broke down. Kahlo earnestly stares directly at the viewer, depicted in front of a background densely filled with leaves, as if trapped in a jungle. She wears a cape made of thin branches protruding with sharp thorns. A monkey sits on her right shoulder symbolizing evil (her pet monkey Fulang-Chang) and a black cat on the opposite side symbolizes bad luck. A black hummingbird is suspended from her neck, a symbol of the Aztec god of war. The work is sombre and evokes the pain and sadness the artist felt at the time. All her works featured elements of nature: animals, exotic plants and trees native to her homeland Mexico. Many of the plants she featured were taken from her garden at La Casa Azul, including deep-pink bougainvillea that she so famously wore in her hair.

After stints in New York and Paris, where she moved in circles with artists Pablo Picasso and Joan Miró and on the periphery of the Surrealist group, she remained focused on creating brutally honest and self-reflective work. She unashamedly asked questions of identity, postcolonialism, gender, class and race in Mexican society. Kahlo addressed these issues by including iconography, pre-Columbian and religious symbols and Aztec mythology in her work. You will regularly see monkeys, skeletons, skulls, blood and hearts in her paintings – these are typical of Aztec mythology.

When it comes to Kahlo you'll create a botanical world like her Mexico City home. Create a Kahlo-inspired self-portrait and re-design her celebrated iconic wardrobe.

Using a black pen, draw the missing side of these leaves, similar to Kahlo's as depicted in *Roots* (1943).

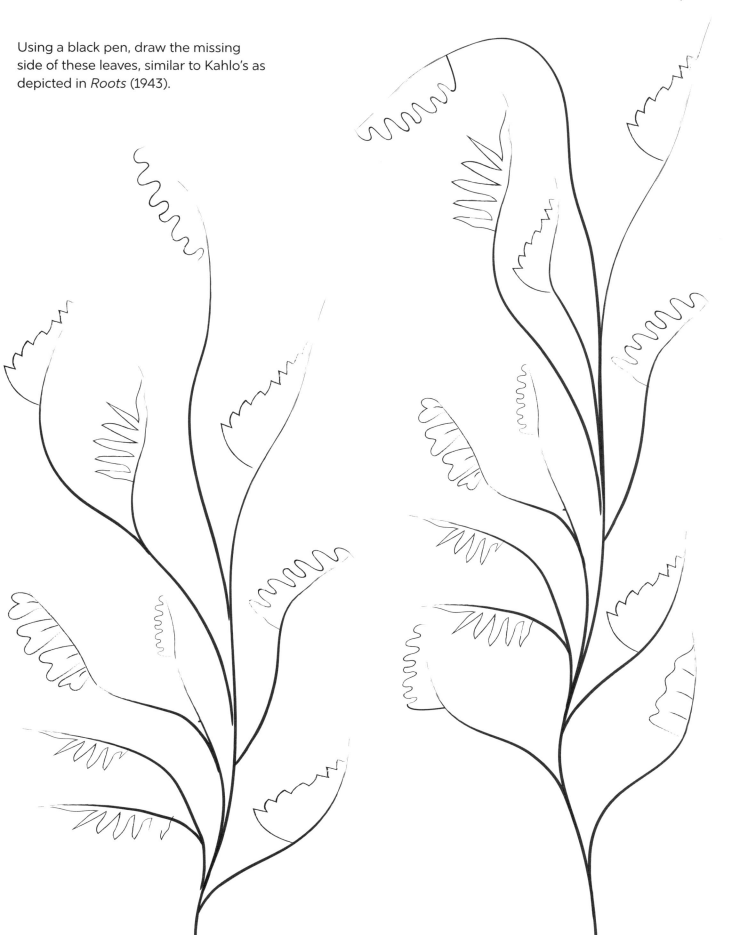

Cover the outside of Kahlo's house with the tropical leaves you've just learned to draw. Colour them with four different shades of green. Use crayons. Bear in mind branches might hang from above, either from a tree or the roof.

Kahlo would depict herself in a dense jungle abuzz with insects and wearing a crown of flowers to symbolize life. Create your own colourful self-portrait here.

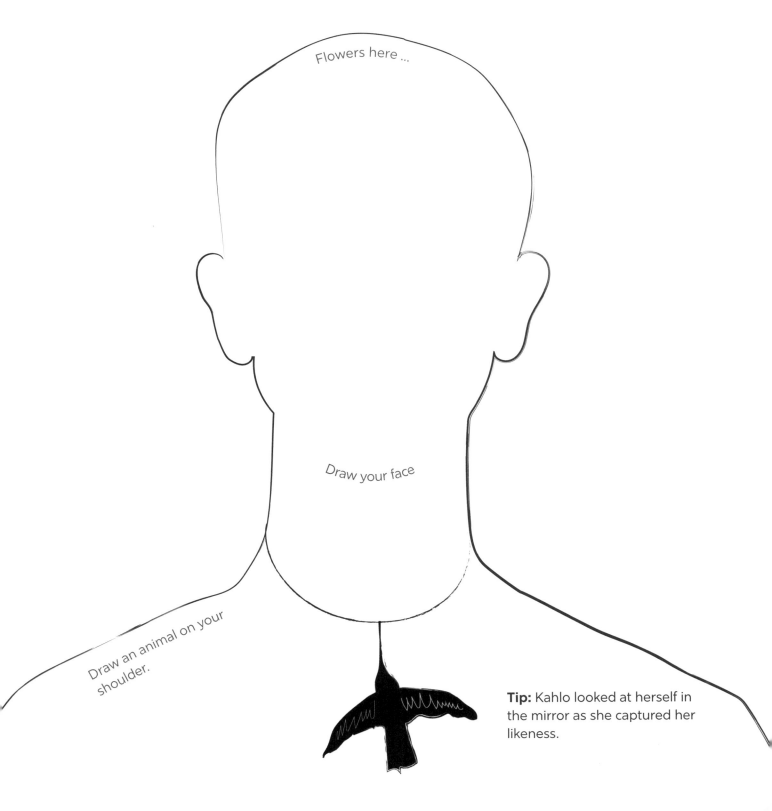

Flowers here ...

Draw your face

Draw an animal on your shoulder.

Tip: Kahlo looked at herself in the mirror as she captured her likeness.

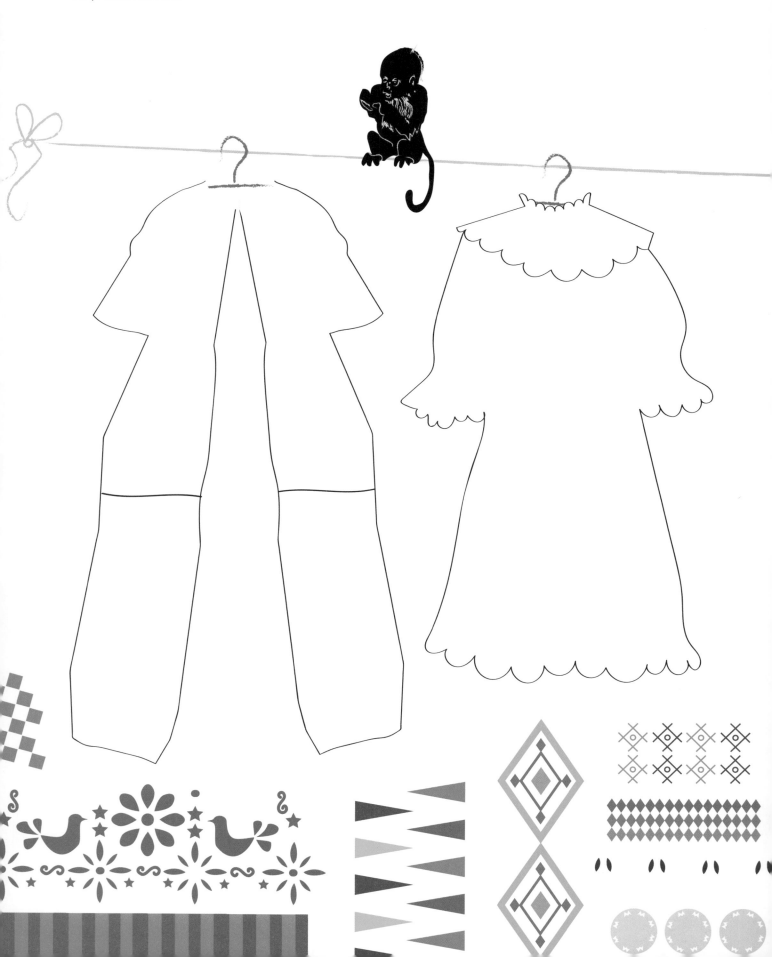

Design Frida's clothes. Below are Mexican-style patterns consisting of geometric shapes and nature images. Take inspiration from them. Use elements from each to create your own patterns. Recreate them using your own colours.

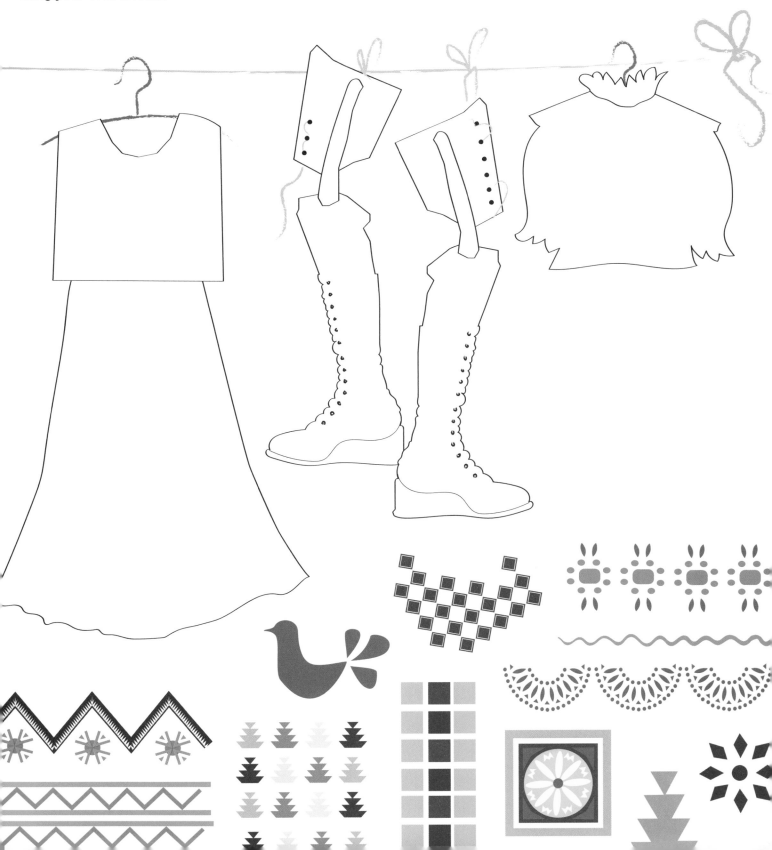

JEFF KOONS

1955 –

Jeff Koons creates installations, paintings and photography inspired by popular culture. He captures familiar everyday objects in costly materials such as metals. He is one of the most successful and influential artists in the world.

His most famous works include *Balloon Dog* (1994–2000), a mirror-polished stainless steel sculpture in the shape of a balloon model poodle, and *Balloon Monkey (Orange)* (2013), a monumental sculpture developed over years of research to ensure he achieved a new level of perfection. The gleaming lacquered and polished surface is seductive and captivating, yet the subject revisits the playfulness and innocence of childhood.

In addition to his 3D work is the Easyfun-Ethereal series: large-scale paintings made up of layered scenes combining cut-out photographs and print-outs of packaged foods, fragments of faces, limbs and hair, and amusement park scenes. The series is concerned with the use of gesture, expression and eroticism, synonymous with American advertising. He nods to classical art in these works with vast landscapes as backdrops. Paintings like these are carefully rendered by a team of assistants to whom Koons allocates a paint-by-numbers system. Templates for these works of art have a number and corresponding (numbered) paints to use, which are custom-made and meticulously mixed to match the original image. Some paintings are so intricate they require brushes as fine as an eyelash. Painters at the studio are instructed to execute a flat surface with no visible brush strokes, no blending, and every inch of the application must be total perfection. It must appear from the outset as a print manufactured by a machine. Employing this technique takes quality control to another level.

You're going to imitate the artist's large-scale animal figures using anything metallic and shiny you can possibly find. Get stretching your balloons ready to model in the form of a Koons-style dog. Just like an assistant in the Koons studio, colour a detailed paint-by-numbers artwork reinterpreting one of his mixed media fantastical scenes. Test your precision skills as you recreate a coloured backdrop inspired by the artist's Easyfun-Ethereal Series.

Inspired by *Balloon Monkey (Orange)* give these figures a shiny, metallic or mirrored surface by applying any suitable materials you might find – sequins, sweet wrappers, papers, etc.

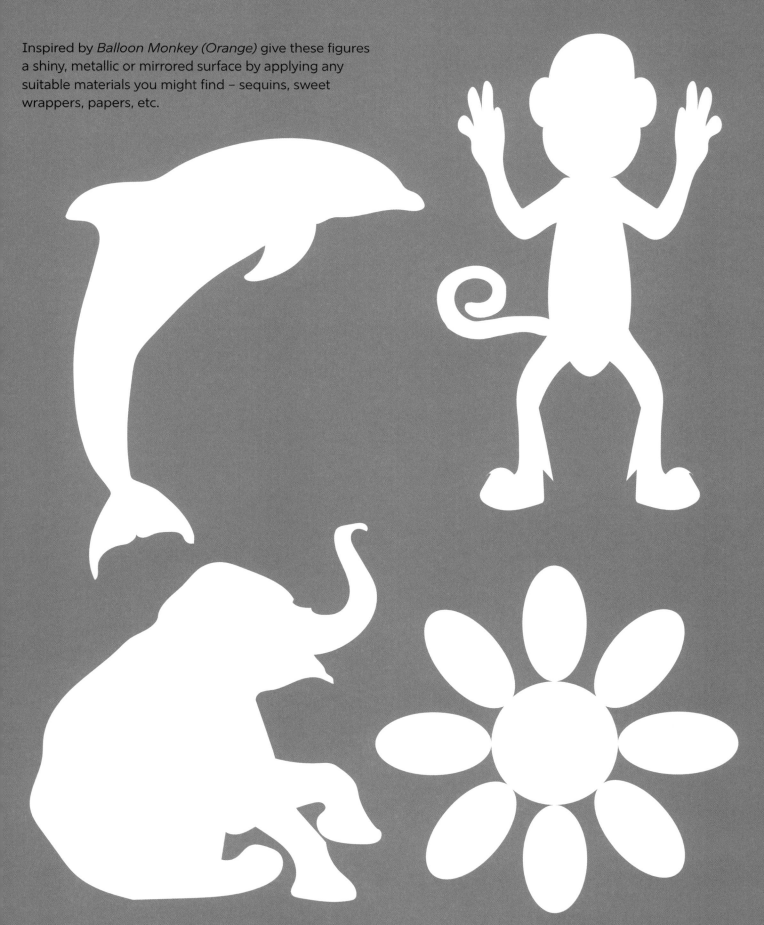

You'll need some modelling balloons for this activity. Follow these step-by-step instructions to create a balloon dog.

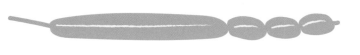

1. Inflate a pencil balloon leaving three inches at one end uninflated for the tail. Twist the front of the balloon into three sections about one inch long.

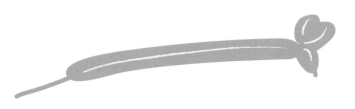

2. For the head, twist the first and third smaller sections together to form a snout and two ears.

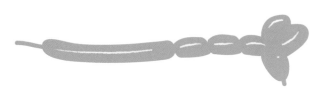

3. Working from the head, twist another section measuring two inches and two more sections measuring three. Twist the first section with the third for the front legs.

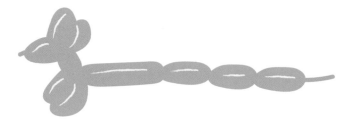

4. Twist three four-inch sections next to the front legs. Twist the first and third sections to form the body, hind legs and tail.

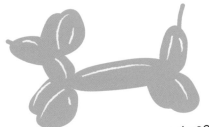

5. Adjust the head and straighten the legs a little. Voila!

Note: When you twist, do it three times so it's secure.

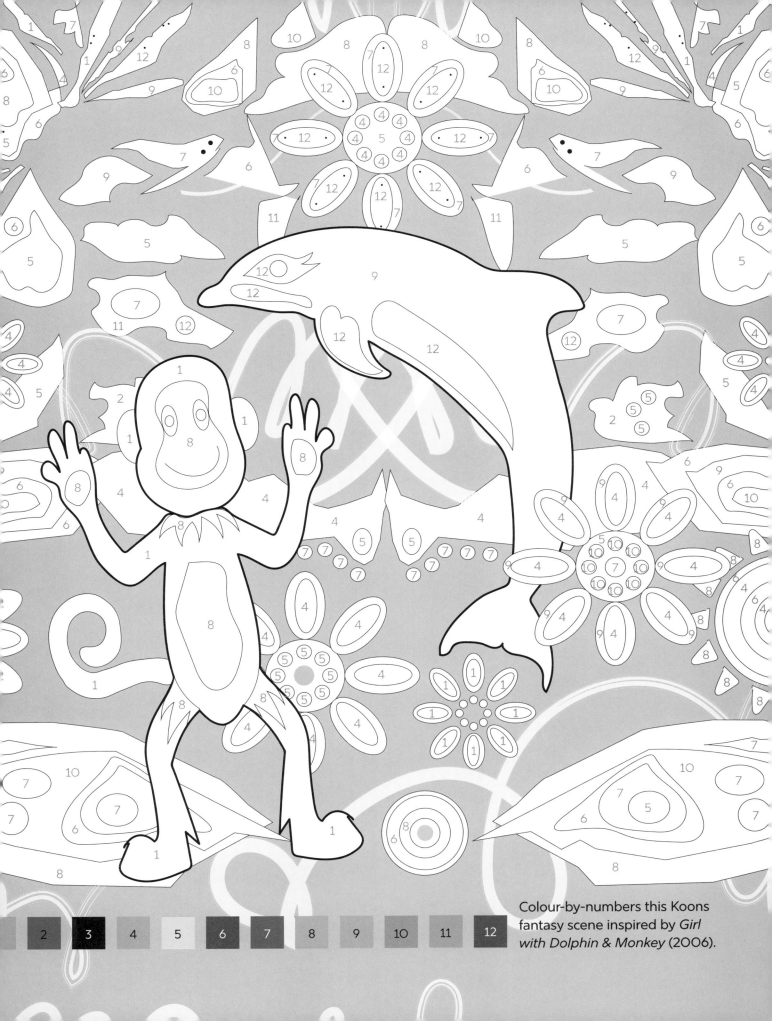

Colour-by-numbers this Koons fantasy scene inspired by *Girl with Dolphin & Monkey* (2006).

Reproduce the artwork opposite on this page. It is inspired by Koons's Easyfun-Ethereal series. Use crayons and add any overlapping lines or marks using gel pens. You MUST be exact.

YAYOI KUSAMA

1929 –

Yayoi Kusama is a sculptor, installation artist and painter whose work is defined by the polka dot. She has also influenced the world of fashion, and created poetry and performance art. Her parents objected to her desire to become an artist, even going so far as to throw away her childhood drawings. Still, that didn't stop her and she fled Japan for art school in New York.

Dots entered Kusama's creative vision when she was a child, having experienced a hallucination in a field full of flowers. The artist recalls how the flowers started talking to her, her vision distorted and the field appeared full of endless dots. Kusama transports the viewer into her own hallucinogenic experiences which have shaped her vision for much of her career.

Her most famous works include *Fireflies on the Water* (2002), an installation featuring a small, dark room lined with mirrors. A pool of water stands in the centre of the space into which a viewing platform protrudes. Small lights hang from the ceiling and reflect in the water, creating a magical immersive experience reminiscent of her earliest mirrored installation, *Infinity Mirror Room* (1965). The pumpkin is an example of a favourite motif of Kusama's and has featured in another of the artist's mirrored rooms, *Mirror Room (Pumpkin)* (1991) as well as paintings on canvas such as *Pumpkin* (1990).

Kusama believes that by covering her paintings and drawings with dots and then extending the pattern beyond the canvas and into the room on objects and even clothes, everything becomes one illusionary universe. Transport yourself into a unique polka dot-filled universe. Explore polka dot patterns in various formations and use them to breathe new life into everyday objects and spaces. Create your very own mini installation inspired by *Mirror Room (Pumpkin)* and continue transporting Kusama's joyous polka dot world, starting on the pages of this book, to beyond on a variety of surfaces.

Continue these polka dot patterns. Use a black pen.

Draw polka dot patterns all over these household items.
Use black ink.

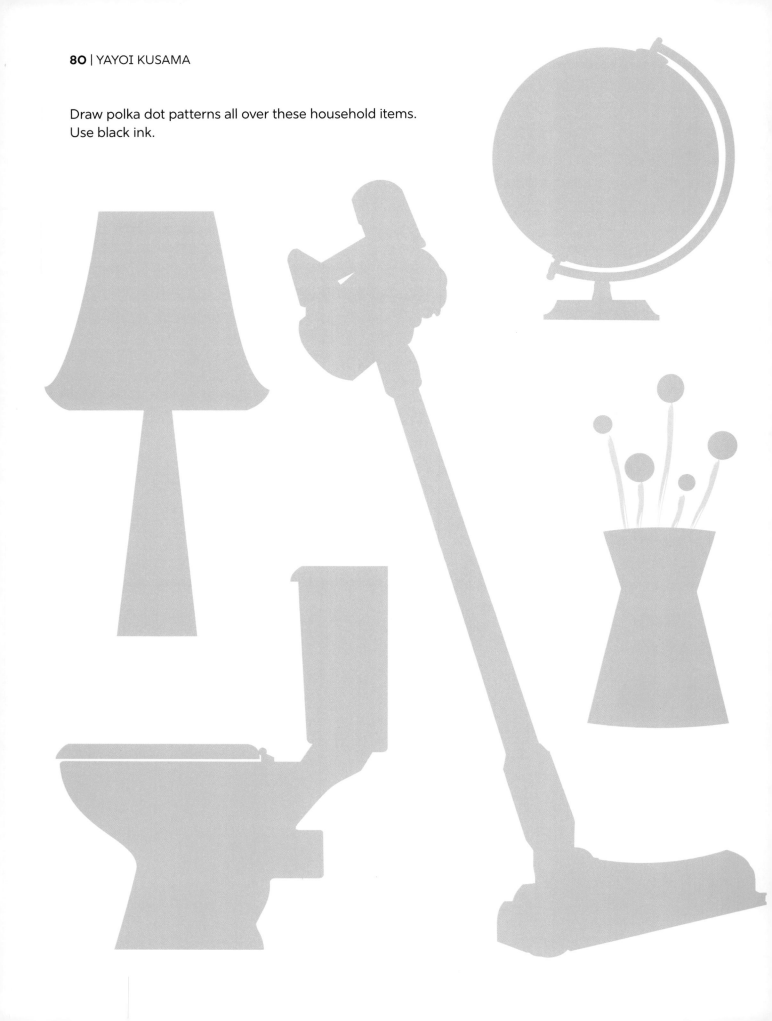

Cover this part of Kusama's childhood city in a polka dot pattern. Use just two colours for each element of the drawing.

Like this ...

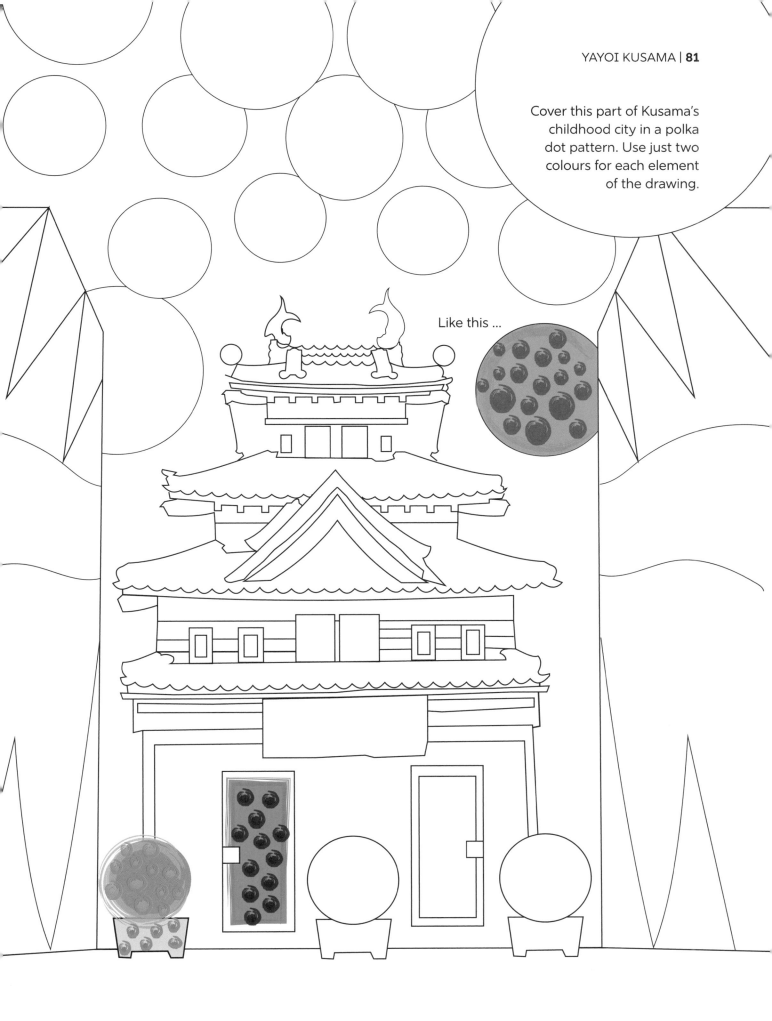

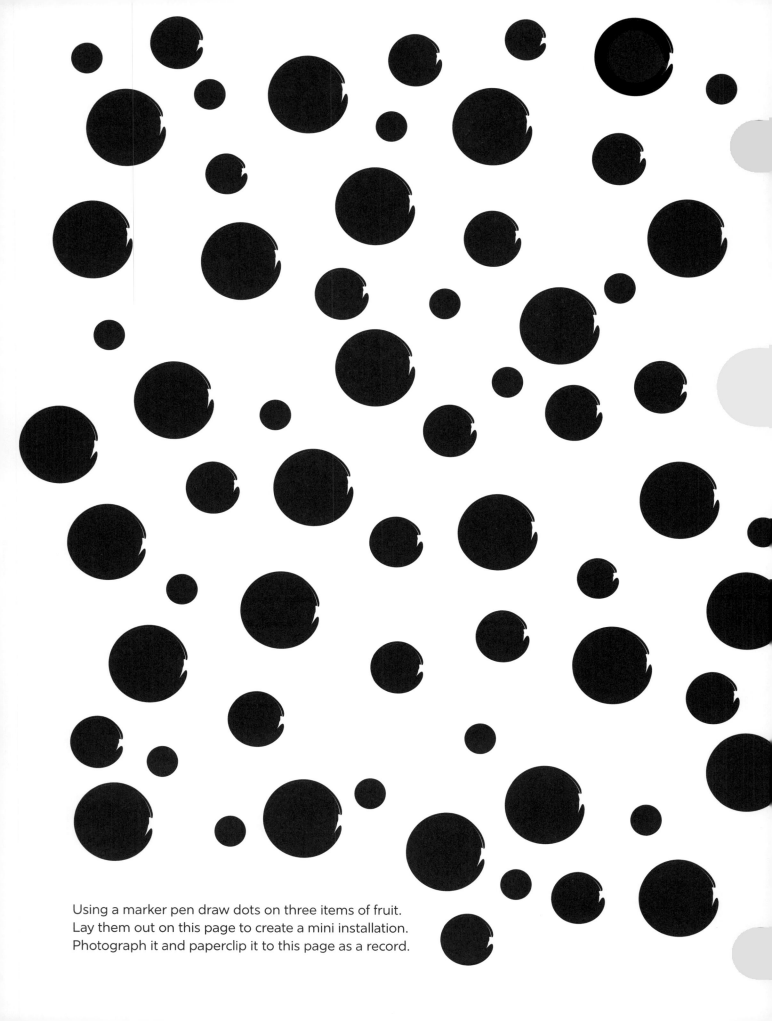

Using a marker pen draw dots on three items of fruit.
Lay them out on this page to create a mini installation.
Photograph it and paperclip it to this page as a record.

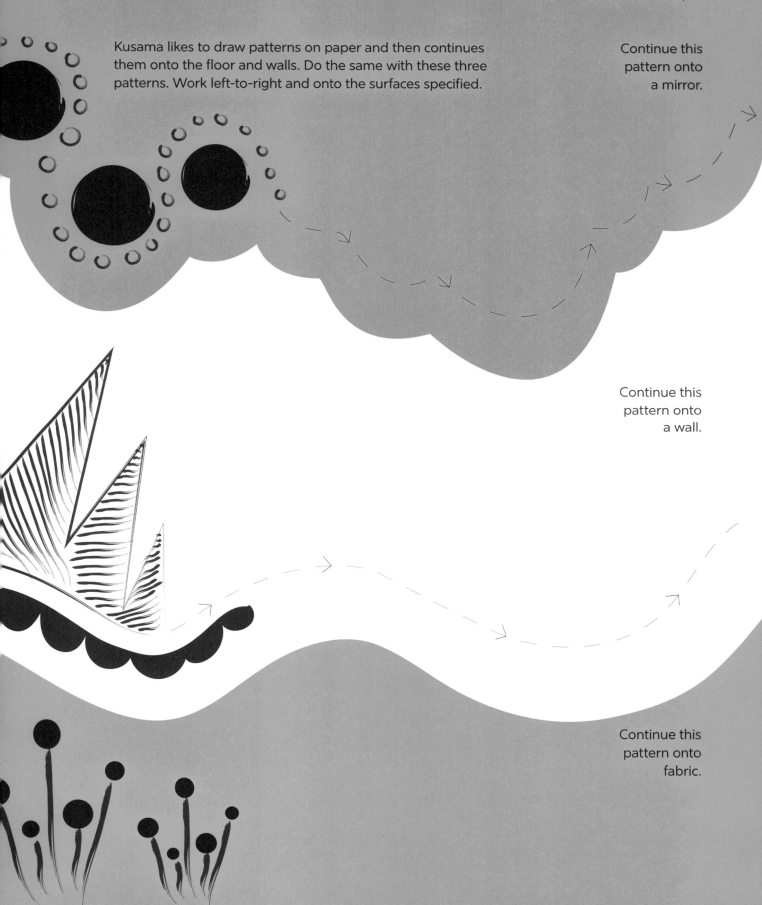

Kusama likes to draw patterns on paper and then continues them onto the floor and walls. Do the same with these three patterns. Work left-to-right and onto the surfaces specified.

Continue this pattern onto a mirror.

Continue this pattern onto a wall.

Continue this pattern onto fabric.

HENRI MATISSE

1869 – 1954

Henri Matisse was a painter, draughtsman and sculptor. He also created graphic arts (etchings, linocuts, lithographs, and aquatints), and book illustrations. With his exuberant, bold and brightly coloured artworks, he became one of the most influential artists of the twentieth century. Matisse was inspired by the landscape, objects, nature, people and the female figure. Picasso was his fan but also his rival.

His most famous works include *Dance* (1910), a hugely significant painting considered by much of the art world to have paved the way for the modern art movement. The painting is wonderfully fluid and vibrant, featuring five human figures holding hands and dancing in a circle. With its restricted colour palette of red, blue and green, it hints at the simplistic mastery that would become the artist's legacy.

Today Matisse is known primarily for his bold paper cut-outs, created in the final years of his life. This technique essentially involved 'drawing' with scissors. These radical, inspiring cut-outs formed murals, costumes and stained glass including *The Snail* (1953), a nine-foot-square colourful masterpiece. By drawing things around him using scissors, Matisse simplified form. The shapes he cut out became an abstract silhouette. It was fine that edges were uneven, this gave every element character. He had fun capturing his subjects in unrealistic colours and playing with scale; sometimes he would make things much larger than they were. Even though the cut-outs were flat, their bold colours made them appear almost sculptural in form. Once he had several cut-outs, he would combine them by making a scene, mural or decorative pattern.

Matisse's cut-out technique was key to developing his final creation, the Chapel of the Rosary in Vence (1948–51). This church, located near Nice, France, is an architectural gem. The work in its entirety showcases his many oeuvres and the ease with which he turns his hand to most art forms. In addition to the architectural design, the church features furnishings, stained glass, sculptures, murals and ecclesiastical costumes, all designed by Matisse. The chapel's purity and stripped-back aesthetic is just what Picasso so admired.

'Draw' with scissors like Matisse, starting with simple shapes. Cut out your dinner and stick it on a plate and challenge yourself to cut out everyday objects.

Fold a piece of paper in half and cut out each of these shapes on the fold. Unfold the paper and Matisse's shape will be revealed.

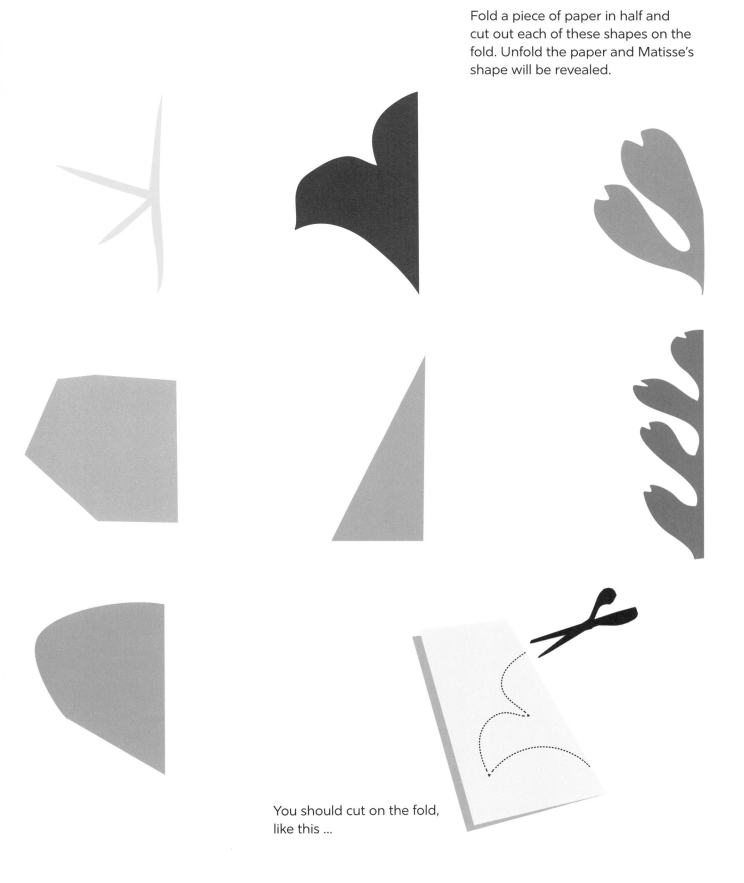

You should cut on the fold, like this ...

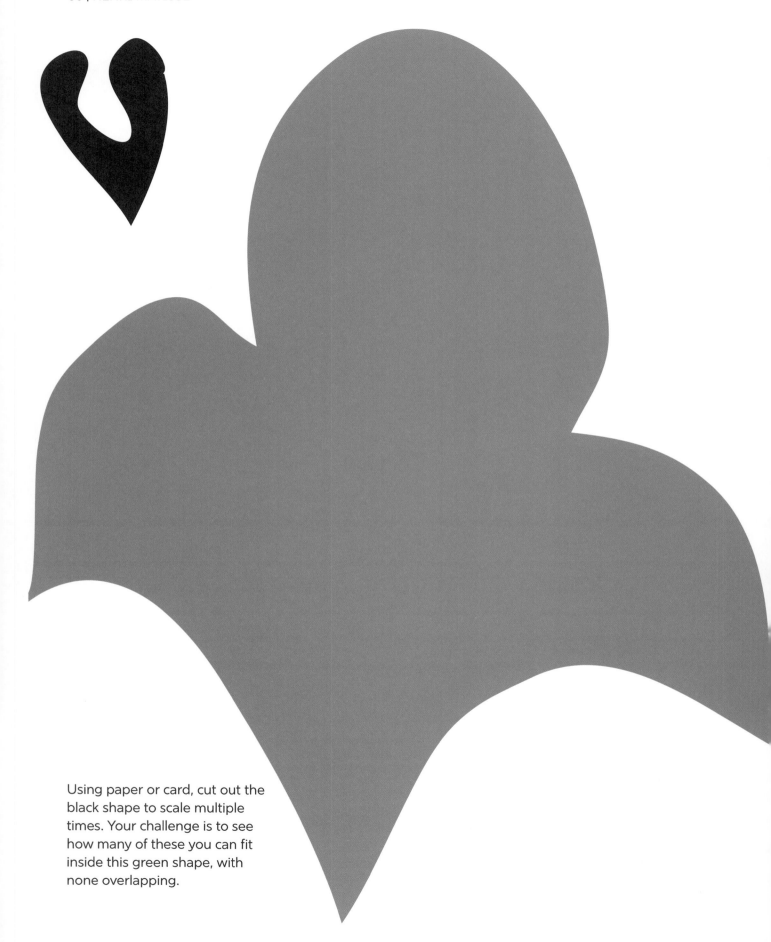

Using paper or card, cut out the black shape to scale multiple times. Your challenge is to see how many of these you can fit inside this green shape, with none overlapping.

Using brightly coloured paper, cut out your dinner and put it on this plate.

Cut these objects out of paper.
Use different coloured paper for
each. Stick them on to the objects
below to see how accurate you are.

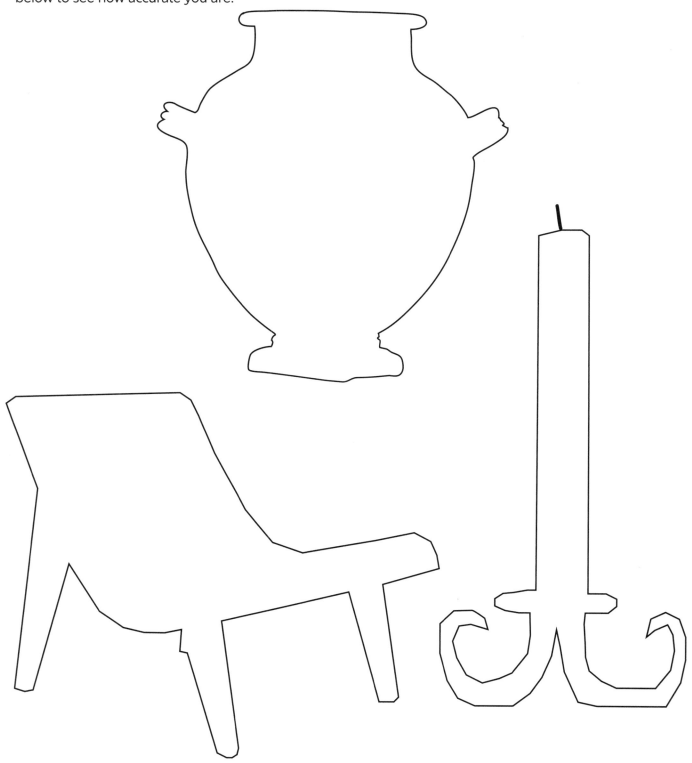

REMEMBER: Imperfect edges are good!

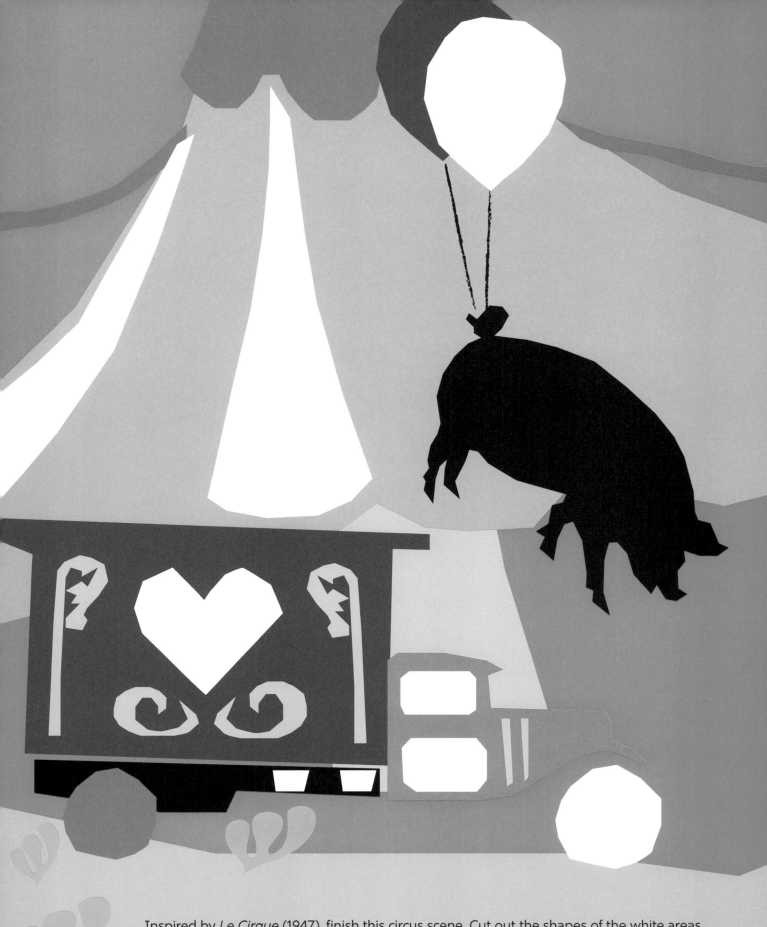

Inspired by *Le Cirque* (1947), finish this circus scene. Cut out the shapes of the white areas using coloured paper and glue them in place. Add more cut-outs of your own.

JOAN MIRÓ

1893 – 1983

Joan Miró created paintings, sculptures and ceramics. He was inspired by the universe, the moon and the stars. His work is wonderfully colourful and often combined red, blue, yellow, green, black and white in singular tones.

His most famous works include *The Farm* (1922), a depiction of his family-owned farm in rural Spain. It's stylistic and entertaining with all its eccentric details, use of symbolism and play with perspective. This work is important because it shows his step away from fauvism and cubism into surrealism. Some years later he created *Constellations* (1940–41), which demonstrated a clear stylistic transformation unlike anything he'd produced before. This series of gouache works on paper was inspired by celestial symbolism and also included women and birds. The work showcases his unique methodical process incorporating his own symbolic language inspired by the universe. The iconography that made up *Constellations* would become a major feature of Miró's work for the duration of his life. In his final year he created *Dona i Ocell (Woman and Bird)*, inspired by *Constellations*. This phallic seventy-two-feet high sculpture features women and birds in large colour-block geometric and hourglass forms.

Like many artists in this book, Miró moved to Paris at the beginning of the twentieth century. In 1924 he joined the Surrealist group. Like his contemporaries, he would slowly develop more dreamlike subject matters. He also began to draw unconsciously at this time, a technique known as automatic drawing. He went against the grain of the traditional idea of drawing, preferring to draw instinctively, making marks 'in the moment'. He would draw at night when he said he would capture shapes he saw on the ceiling.

You'll explore Miró's unique methodical process and symbolic language inspired by the universe, the moon and the stars. Play with shapes and manipulate line formations. Explore the freedom of drawing and mark-making. Allow your subconscious to lead artistic fluidity.

Using a black pen, draw twenty shapes of different sizes on the line. You'll see how the line divides the shape into two. Colour each side in different colours. Be fairly loose – your shapes don't have to be perfect.

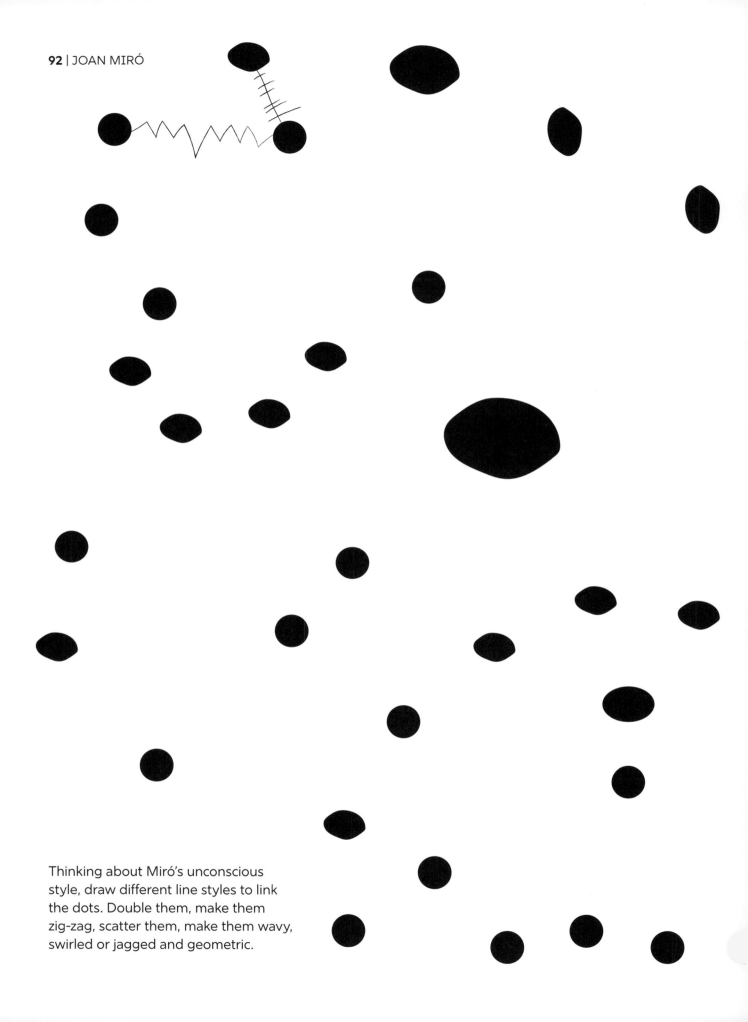

Thinking about Miró's unconscious
style, draw different line styles to link
the dots. Double them, make them
zig-zag, scatter them, make them wavy,
swirled or jagged and geometric.

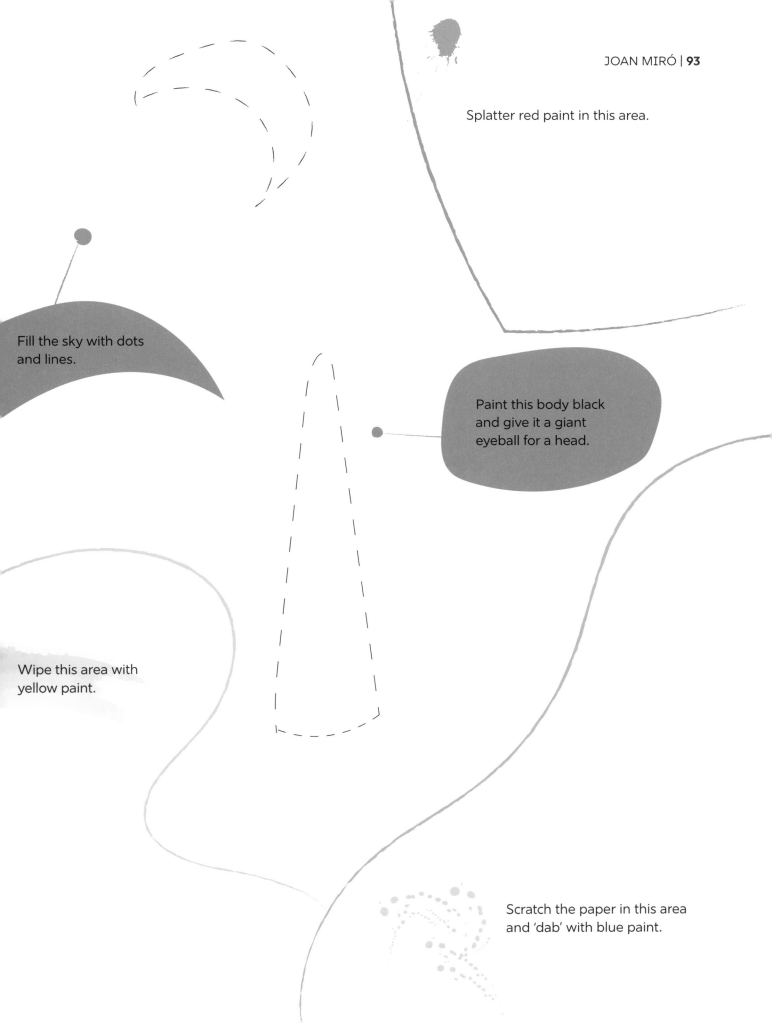

Splatter red paint in this area.

Fill the sky with dots and lines.

Paint this body black and give it a giant eyeball for a head.

Wipe this area with yellow paint.

Scratch the paper in this area and 'dab' with blue paint.

Water down some paint. Using your
fingers, give this face a body and hair.
Be linear and only use primary colours.

If you had to leave planet Earth, what five things would you take with you? Doodle them on this moon.

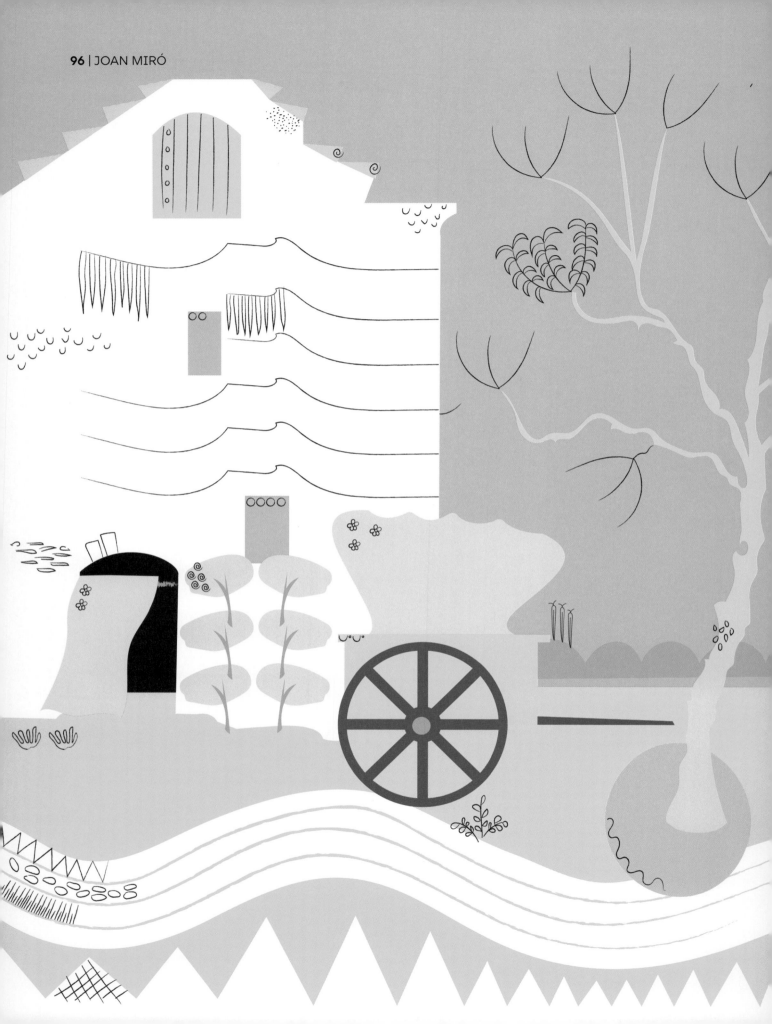

Areas need to be completed on this scene. Try to emulate the details already drawn on the page – be intricate and fill the spaces. Keep them in their specific area – doing this will create bold surface patterns and overall consistency.

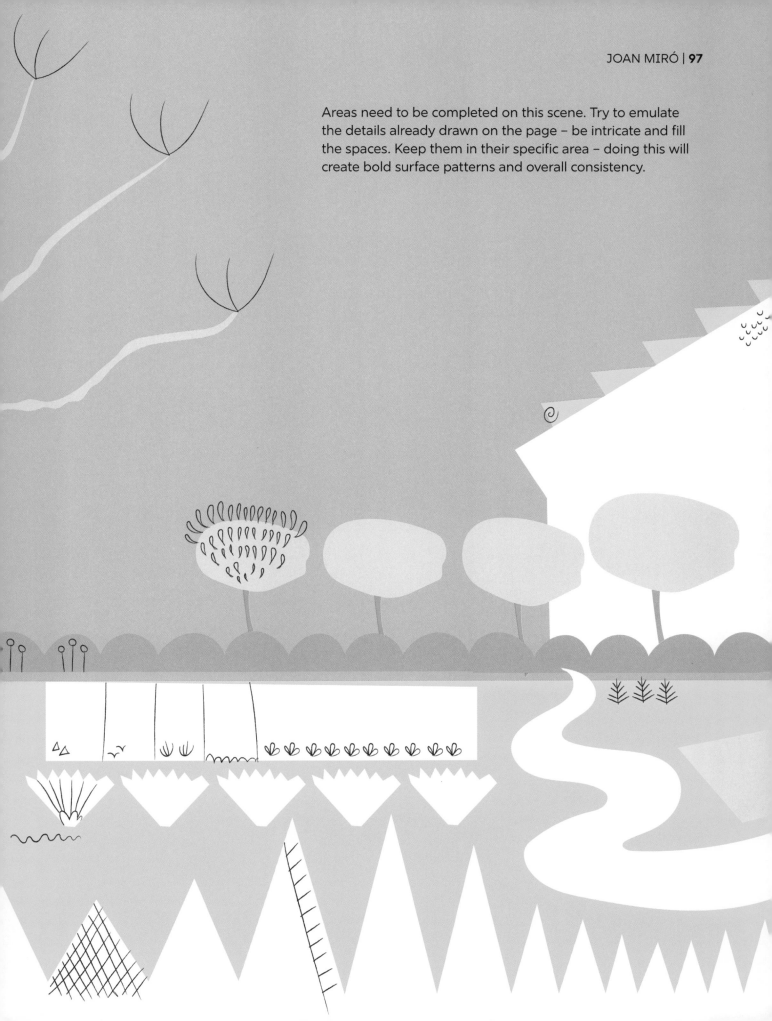

PABLO PICASSO

1881 – 1973

Pablo Picasso was a painter, sculptor, printmaker, ceramicist and theatre designer. His most famous works include *Three Musicians* (1921), *Les Demoiselles d'Avignon* (1907) and *Guernica* (1937). Famously, Picasso recalled how it took him just a few years to draw like a master but a lifetime to draw like a child. His father was also an artist and he formally trained Pablo from the age of seven. In 1901 Pablo started to leave realism behind and experimented with symbolism through colour. First came his Blue Period, featuring subject matters ranging from beggars and prostitutes to emaciated figures, including children. He was influenced by his travels through impoverished areas of Spain, en route to Paris, and the death of his friend, Carles Casagemas. From 1904 Picasso entered his Rose Period. He created various works in pinks and oranges, which were lighter and more upbeat than the Blue era, symbolizing his happier state of mind.

From 1907 Picasso introduced the first signs of cubism, the movement he pioneered and went on to make him the most influential artist in history. He developed cubism by analysing the human form and determining its anatomy as simply a group of shapes. He visited a museum in France and saw African artefacts, including masks that, he recognized, were created in this way. *Les Demoiselles d'Avignon* shows how he enthusiastically left realism behind and embraced cubism, with three figures depicted with faces inspired by sculptures found in his native Spain, and two containing much more striking features, similar to African masks.

Picasso's use of cubism ensured strong, powerful works of art. The fragmented and abstract appearance, often with several viewpoints of a subject, fittingly reflected a transformative, war-ridden and restless early twentieth century.

Try, like Picasso, to abandon the tradition of perspective drawing and look at subjects from many angles. Abstract, distort and fragment your world with basic cubism. Create your very own cubist self-portrait inspired by his portrait of Dora Maar.

Divide this page further using
six more lines at various angles.
Using pastels, colour-in the
geometric shapes you form.

Reuse these shapes by drawing
one or two inside another. Vary
the scale of your shapes and
draw them on different angles.
Colour-in your shapes.

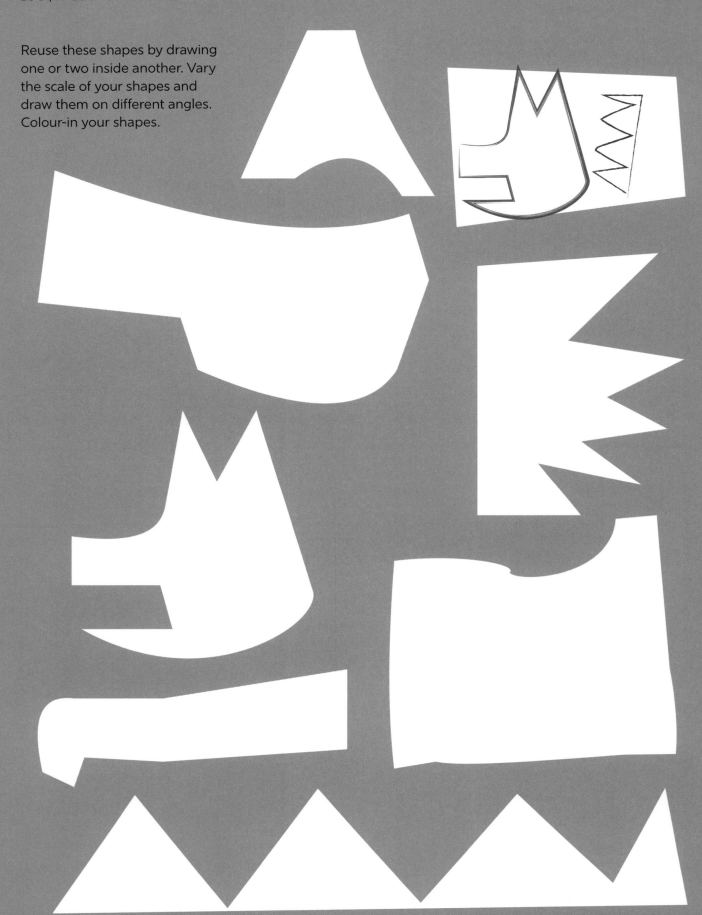

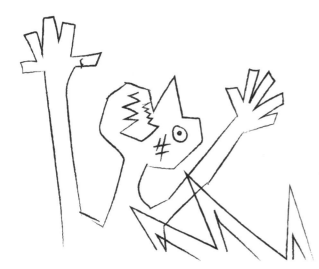

Picasso's anti-war painting *Guernica* depicted screaming people, frightened horses and flames. Draw things you associate with war on this page. Your lines must be straight. No curves are allowed. Overlap elements, as with the flames on this figure.

Draw your own versions of these objects found at home directly on top of these. Use crayons in a contrasting colour. Highlight any key features using black ink just as I have here.

Picasso often displayed many views of one object in this way.

Complete this self-portrait. Use a crayon and draw your facial features located according to the numbers. **1.** Mouth **2.** Right eye (include your eyeball, lid and lashes) **3.** Hand **4.** Left eye **5.** Hair (just 3 lines) **6.** Your right ear.

CINDY SHERMAN

1954 –

Cindy Sherman trained as a painter but turned to photography so she could concentrate more on her ideas and deliver them faster. Since the 1970s Sherman has been the queen of the selfie, photographing herself dressed-up as different stereotypes. She is primarily focused on social identity, diversity and identity in general.

Sherman's most famous works include *History Portraits* (1988–90), a photo series in which she recreates Old Master paintings by artists including Caravaggio and Raphael. *Untitled Film Stills* (1977–80) brought her international fame. The series explores the artist's fascination with the film world, particularly its female characters. Seventy black-and-white photographs capture her evoking typical womens' roles in arthouse films, popular B-movies and film noir. Characters include a librarian, a seductress and a hillbilly. The series highlighted the strength of women, their determination and independence in modern society. This was in contrast to the original 1950–60s film heroines she was referencing, who were engulfed in vulnerablity. Sherman's heroines are the modern re-make, powerfully re-establishing a centuries-old female image.

Her working methods are parallel with that of a filmmaker. Like the writer–director, she develops character profiles, styles them in wardrobe ready to perform and they act out someone entirely different to themselves. The difference is Sherman's film never comes to fruition. Instead we are presented with stills of characters: their facial expressions and wardrobe are all that indicates something about that person.

Transform yourself and people you know into characters contrary to their personality and everyday image. Use simple props and costume to alter identity on the first impression of various social stereotypes and make Cindy a serious fashionista.

Draw faces of your friends or family onto these figures taken from world-famous art.
Pair each person with the character least like themselves.

Sherman transforms herself into other people using clothing and props commonly associated with them. Transform yourself into both of these characters. Key wardrobe pieces have been outlined. Once you're fully transformed take a selfie, print it and stick it on the page.

TRANSFORM YOURSELF INTO:
A RAPPER

Fix your selfie here.

You'll need:

1. A pair of jeans, a zip-up jacket and a white T-shirt. These items MUST be at least three sizes larger than your usual, size, AKA super baggy.

2. A large metal or gold necklace, a chain preferably. If you have one with a giant medallion, even better.

3. A baseball cap. (Wear it West side.)

4. Two watches. Wear them both on the same wrist.

TRANSFORM YOURSELF INTO:
A GREEK GODDESS

Fix your selfie here.

You'll need:

1. A VERY large bed sheet. Drape it over your body. Knot it at one shoulder to secure it. Ensure it is concealing your body.

2. Use a thin belt at the waist. Clinch it in and accentuate those gorgeous curves!

3. Pick twenty or more large leaves off a tree or bush. Spray paint them gold. Once dry, use strong glue to attach them to a hairband. Make sure they point upwards so you achieve the authentic goddess look.

American football helmet Red mohawk hair piece Clown mouth & nose

Red lipstick & blouse A crown A feather boa

Snorkel & goggles Bunny ears A straw hat

Transform these people using images of props and costume cut-outs from magazines and other printed media. Stick them on. Each person is labelled with the prop or costume piece you need.

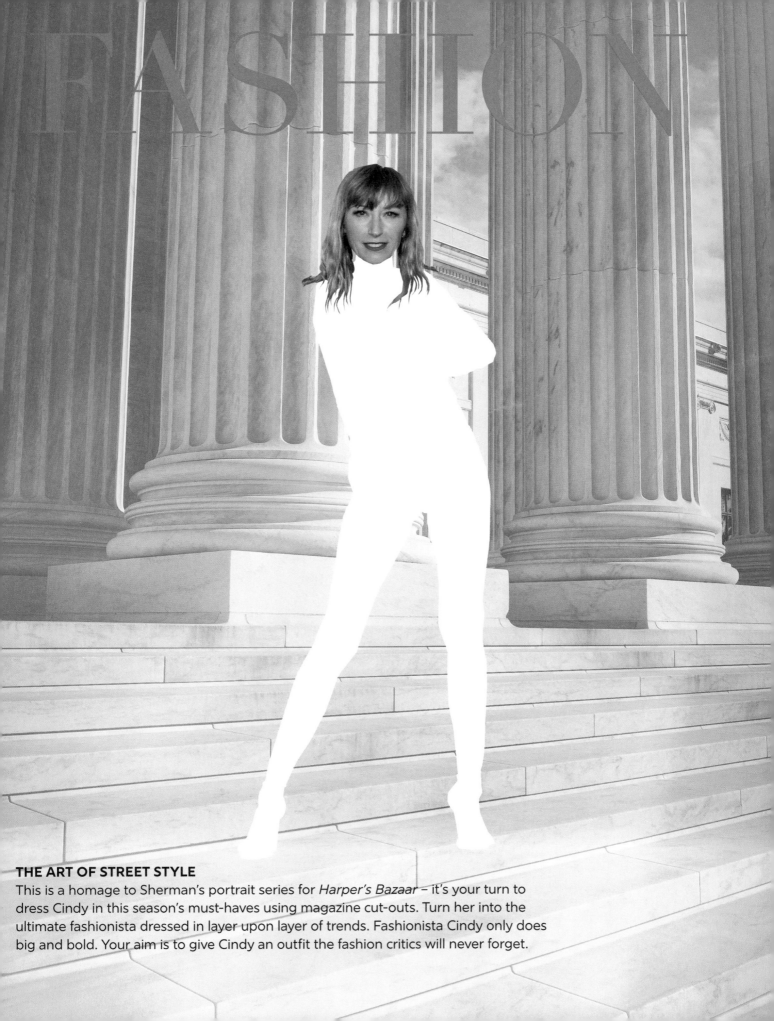

THE ART OF STREET STYLE
This is a homage to Sherman's portrait series for *Harper's Bazaar* – it's your turn to dress Cindy in this season's must-haves using magazine cut-outs. Turn her into the ultimate fashionista dressed in layer upon layer of trends. Fashionista Cindy only does big and bold. Your aim is to give Cindy an outfit the fashion critics will never forget.

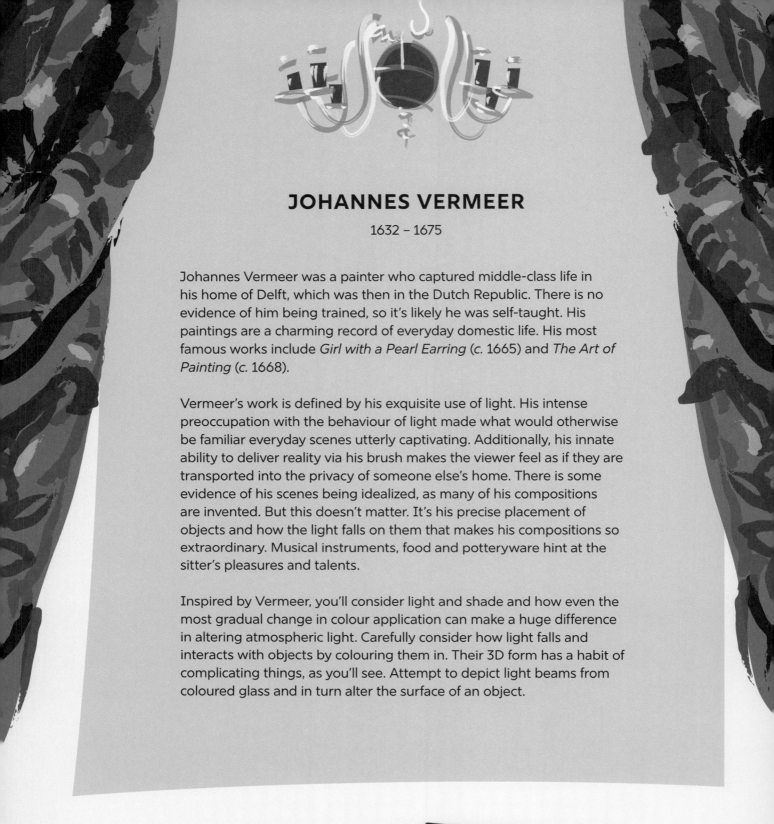

JOHANNES VERMEER

1632 – 1675

Johannes Vermeer was a painter who captured middle-class life in his home of Delft, which was then in the Dutch Republic. There is no evidence of him being trained, so it's likely he was self-taught. His paintings are a charming record of everyday domestic life. His most famous works include *Girl with a Pearl Earring* (*c.* 1665) and *The Art of Painting* (*c.* 1668).

Vermeer's work is defined by his exquisite use of light. His intense preoccupation with the behaviour of light made what would otherwise be familiar everyday scenes utterly captivating. Additionally, his innate ability to deliver reality via his brush makes the viewer feel as if they are transported into the privacy of someone else's home. There is some evidence of his scenes being idealized, as many of his compositions are invented. But this doesn't matter. It's his precise placement of objects and how the light falls on them that makes his compositions so extraordinary. Musical instruments, food and potteryware hint at the sitter's pleasures and talents.

Inspired by Vermeer, you'll consider light and shade and how even the most gradual change in colour application can make a huge difference in altering atmospheric light. Carefully consider how light falls and interacts with objects by colouring them in. Their 3D form has a habit of complicating things, as you'll see. Attempt to depict light beams from coloured glass and in turn alter the surface of an object.

Complete these colour gradients with crayons. Work from left to right starting with the lightest shade. As you work towards the darkest shade, gradually get darker by increasing the pressure you apply on the paper with your crayon. The mid-tone in the centre will help you achieve a smooth transition.

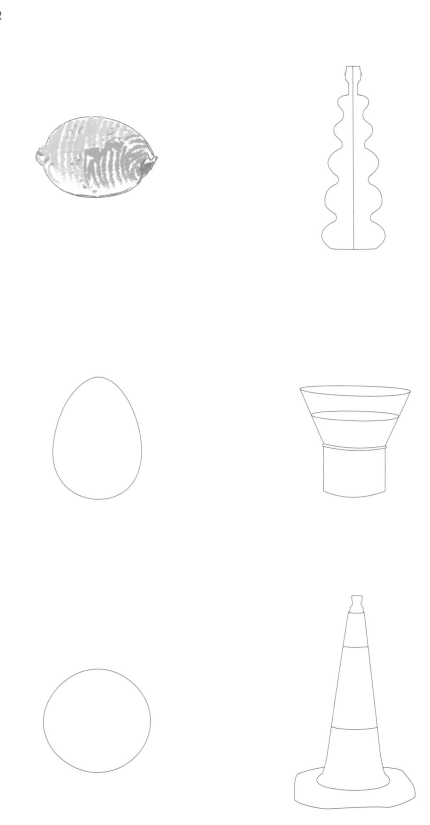

Just like Vermeer, define the light coming through the window and falling on these objects. The lemon has been coloured to guide you – the light from the window comes from the left side thus the lemon is illuminated more on the left. Use crayon to shade each object. Carefully consider the form of the objects, any curvatures, turns or finer details.

The colours fall on
this angle ...

Sunlight shines through this stained glass window, reflecting all the
colours onto the vase. Apply the colours using watercolour paints.

Record the light of day. Leave the book open
on this page on a window sill on a sunny day.
Position a mug on the 'dot'. Every hour draw
around the shadow it creates.

KARA WALKER

1969 –

Kara Walker is an American painter, silhouettist, printmaker, filmmaker, and professor, who explores many powerful themes in her work. She is renowned for her large-scale tableaux of black cut-paper silhouettes, featuring characters in various scenes that often bring history to life and highlight issues, including slavery and violence. Art is her voice.

Walker looks to books for inspirational imagery. She selects whole or partial images from historical texts and combines them to create entirely new panoramic scenes. She chooses to silhouette the scenes in black, referencing African-American history as well as the silhouette portraits collected by the white bourgeoisie during the height of the slave trade. Each piece appears fantastical, yet there's a feeling of eeriness and reality due to the life-size scale.

In referencing historical imagery, her work leads us to ask questions about our society. Walker is on a quest for more equality and social change and it's her ability to deliver an informed argument with integrity that makes her such a powerful artist. Importantly, Walker renews any non-black perceptions of the past – the viewer is presented with startling truths and wrongdoings in history. We are reminded that what we are told is the result of smoke and mirrors and that today we still exist in a very unequal world.

In order to fully understand Walker's method you're going to try creating silhouettes. You'll gather imagery to inspire your own silhouette art – just the same as creating a scrapbook. Then you'll learn to put your voice into a final artwork, with the silhouettes you create being incorporated into a scene defining a piece of history and/or delivering a powerful message.

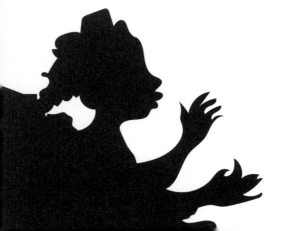

Colour these shapes using a
black fine liner or felt tip pen. Be
meticulous – fill them in completely
so you're left with a silhouette.

Using a black pen, draw objects from home that remind you of something bad or sad on these stalks.

You must focus on the outline, include indents or protruding parts. Then, fill in your outlined objects using black pen, creating a silhouette.

Draw the view you see out of your
window in between these trees.
Make it a silhouette by colouring it in.

Choose a major news event. Illustrate it in silhouette across both pages, referring to imagery sourced online or in newspapers. Pick out things that clearly define what happened, including buildings/landmarks, landscapes, nature, animals and people involved. Silhouette the event in detail. Include both the beginning and aftermath of the event.

Use the black border at the bottom of these pages as a starting point for your scene.

Things could fall from the sky and come from the side ...

ANDY WARHOL

1928 – 1987

Andy Warhol was an American visual artist and film director. He was one of the most influential artists of the twentieth century and a leading figure in the pop art movement. His most famous works include *Marilyn Diptych* (1962) and *Campbell's Soup Cans* (1962). The artist began his career illustrating for fashion magazines including *Vogue*. His early commercial work entailed a fast turnaround, which gave him a real insight into – and curiosity about – the mass-produced consumerist world.

His practice revealed a progressive, ever-changing America driven by commercial advertising and celebrity. Warhol wanted to highlight his country's huge cultural shift and the turbulence that came with it. Soon he found himself at the forefront of the movement with his large-scale, colourful screen-printed works that depicted the likes of movie stars Marilyn Monroe and Elizabeth Taylor. The artist also addressed social and political issues within his work, including the assassination of John F. Kennedy with *Jackie* (1964); the civil unrest in Birmingham, Alabama in *Race Riot* (1963); and he questioned the USA's use of the death penalty in *Big Electric Chair* (1967).

Warhol also depicted familiar generic items from the kitchen cupboard, including more Campbell's soup paintings and *Coca-Cola* (1962). His fascination with everyday objects meant he spoke to a mass audience. As when he depicted an American idol or sex symbol, he excited people and cleverly tapped into what they desired. Warhol was soon seen on kitchen tables, supermarket shelves, TV and movie screens. Remarkably, when we encounter the products and celebrities Warhol depicted, we think of his art.

Warhol will inspire you with his repeated and simple printing methods, colour use and branded products. Create your very own screenprint with a step-by-step guide and turn a drawing of Andy into genuine pop art.

Trace the 'at' sign and can of beans with a 'juicy' ink pen. Blot the wet lines of the images on the empty space of the page to create a 'print' of the drawing. Your blot is going to look imperfect and will fade in areas.

See how many times you can reproduce the same image from your original drawing in this way.

Warhol's first job was illustrating shoes.
Search for colourful patterns and draw them on these shoes.
Use a different colour for each.

1) Fill the page with marks like this using vanishing fluid. Let it dry completely.

2) Cover the page from top to bottom in charcoal. Go over all the marks made with vanishing fluid. Use hair spray to fix it.

3) Wearing rubber gloves, gently rub off the vanishing fluid. The marks will now be the colour of the page.

4) Cut out four flowers twice the size of this one and stick them on the page.

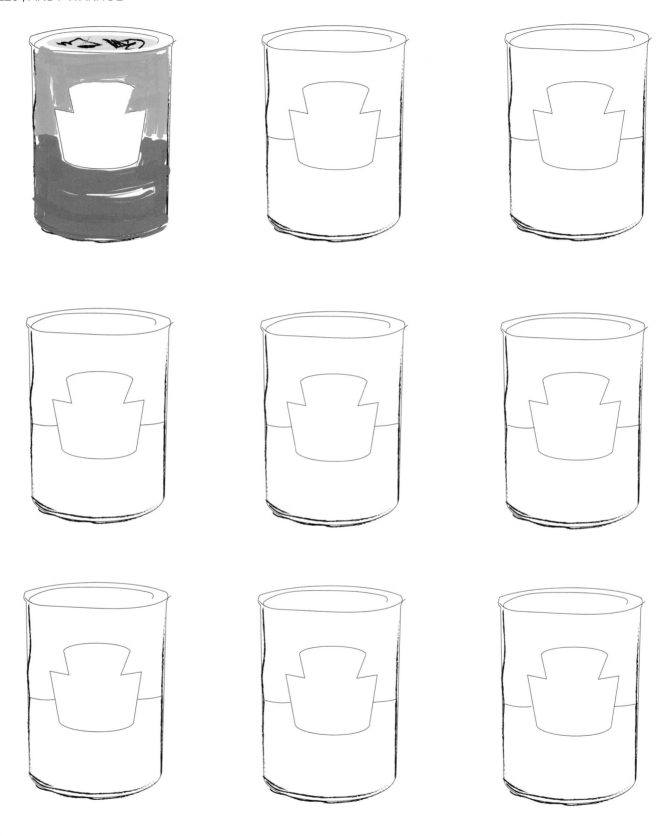

Apply two colours to these food cans, one at the top and one at the bottom. The colours should be bright and a complete contrast to the other. Do not use black.

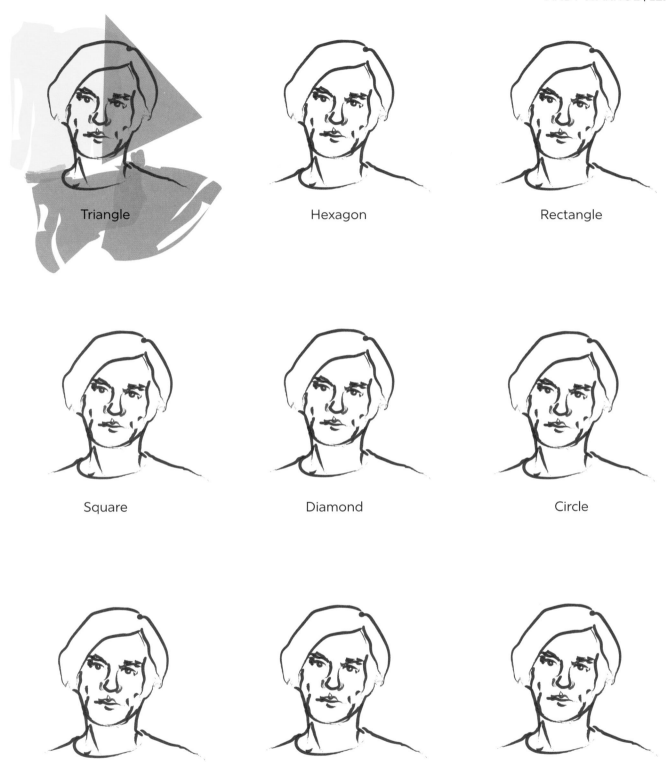

Triangle

Hexagon

Rectangle

Square

Diamond

Circle

Parallelogram

Pentagon

Right-angled triangle

This activity is inspired by Warhol's iconic portraits. Apply three different watercolours of your choice plus the geometric shape given beneath each Andy. Be abstract, bold and ignore the lines. Paint over them.

ART GALLERIES

The galleries and museums listed below hold many of the wonderful, original artworks that have inspired this book. I would urge you to go and have a look at the work of 'the greats' whenever you can – they never fail to take my breath away.

Art Institute of Chicago, Chicago, USA.
artic.edu

Ashmolean Museum, Oxford, UK.
ashmolean.org

Centre Pompidou, Paris, France.
centrepompidou.fr

Dalí Theatre-Museum, Figueres, Spain.
salvador-dali.org

Fundació Joan Miró, Barcelona, Spain.
fmirobcn.org

Gallerie dell'Accademia di Venezia, Venice, Italy.
gallerieaccademia.it

Guggenheim, NYC, USA.
guggenheim.org

Jheronimus Bosch Art Center, s'Hertogenbosch, Netherlands.
jheronimusbosch-artcenter.nl

Louvre, Paris, France.
louvre.fr

Musée Matisse, Nice, France.
musee-matisse-nice.org

Muséo Del Prado, Madrid, Spain.
museodelprado.es

Museo Frida Kahlo, Mexico City, Mexico.
museofridakahlo.org.mx

Museo Picasso Málaga, Spain.
museopicassomalaga.org

Museum of Modern Art (MOMA), NYC, USA.
moma.org

Nakamura Keith Haring Collection, Hokuto, Japan.
nakamura-haring.com

Newport Street Gallery, London, UK.
newportstreetgallery.com

Philadelphia Museum of Art, Philadephia, USA.
philamuseum.org

Rijksmuseum, Amsterdam, Netherlands.
rijksmuseum.nl

Royal Academy (RA), London, UK.
royalacademy.org.uk

Royal Collection Trust, London, UK.
rct.uk

Saatchi Gallery, London, UK.
saatchigallery.com

Tate, UK.
tate.org.uk

The Met, NYC, USA.
metmuseum.org

The National Gallery, London, UK.
nationalgallery.org.uk

Turner Contemporary, Margate, UK.
turnercontemporary.org

Uffizi Gallery, Florence, Italy.
uffizi.it

Whitney Museum of American Art, NYC, USA.
whitney.org

Yayoi Kusama Museum, Japan.
yayoikusamamuseum.jp